LONGWOOD GARDENS

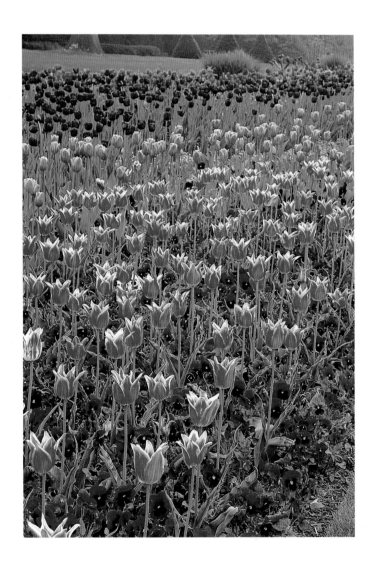

Photography by Larry Albee

Text by Colvin Randall

INTRODUCTION

Longwood Gardens, 30 miles west of Philadelphia in the historic Brandywine Valley, is one of the horticultural treasures of America. Recalling the great pleasure gardens of Europe, Longwood exemplifies a twentieth-century approach to classic Old World traditions.

The gardens were the country home of Pierre S. du Pont (1870-1954), industrial wizard and financier *extraordinaire*. Pierre was the great-great-grandson of French physiocrat Pierre Samuel du Pont de Nemours (1739-1817) and the great-grandson of Eleuthère Irénée du Pont (1771-1834). The latter arrived in the United States from France in 1800 and founded the Du Pont chemical company; the younger Pierre turned it into a corporate empire and used his resulting personal fortune to develop and endow the Longwood property. The public has always been invited to share in its beauty.

The story of Longwood begins more than 200 years before Mr. du Pont's involvement. The region was originally inhabited by the Lenni Lenape tribe, who had for generations hunted, fished, and farmed the rich, productive wilderness. In 1700, George Peirce, a Quaker farmer who had emigrated to Philadelphia in 1684 from Bristol, England, purchased 402 acres of this land from William Penn's commissioners for 44 pounds sterling. Half of the acreage was presented to his daughter on her marriage in 1703. On the remaining land his son Joshua established a homestead in 1709, building a log cabin and clearing the land for a working farm. In 1730, Joshua built the brick farmhouse that, enlarged, still stands today.

In 1798, Joshua's twin 32-year-old grandsons Joshua and Samuel began planting trees, in keeping with the Quaker attitude toward the study of natural history as a way of understanding the Almighty. Their arboretum eventually covered 15 acres and ran in densely planted parallel avenues east and south of the house. It was known within 50 years as one of the finest collections in the nation.

The most conspicuous feature of the Peirce arboretum was a conifer grouping laid out in parallel allées so closely planted that many trees later succumbed to the crowded conditions. There was

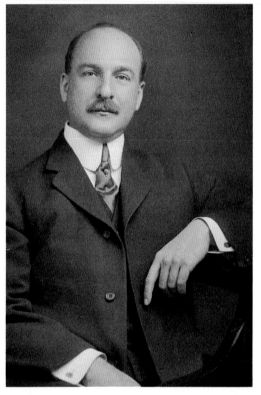

also an excellent representation of deciduous trees from Europe, Asia, and North America. Native species such as tulip trees were collected from the wild. Samuel dug small trees and shrubs locally; Joshua traveled by horseback as far north as the Catskill Mountains of New York and south to Maryland's cypress swamps, returning with plants in his saddlebags. Kentucky coffee trees and cucumber magnolias, both natives of western Pennsylvania, were probably collected on these expeditions. Other trees, such as ginkgos and yellow cucumber magnolias, were acquired through plant exchanges with fellow horticulturists and nurserymen.

Samuel died in 1838 and Joshua in 1851, and the farm was inherited by Joshua's son George Washington Peirce. He carefully maintained the plantings, periodically replacing some of the original trees and constantly adding to the collection. He continued to operate the property as a working farm but developed the arboretum into a pleasure ground, in keeping with the parks movement then sweeping America. Croquet courts, rustic summerhouses, and rowboats were added for the enjoyment of guests. Parties and picnics at Peirce's Park were frequent neighborhood social occasions. When George Peirce died in 1880, the Park was in its prime, both as an arboretum and as a pleasure garden.

George's heirs showed little interest in horticulture and allowed the Park to deteriorate badly. Finally, in 1905, after more than 200 years of ownership, the Peirce family sold the farm. It was resold twice in the next 14 months. The third buyer immediately made arrangements for the trees to be cut. It was the presence of a sawmill on the property that prompted 36-year-old Pierre du Pont to purchase the farm.

Mr. du Pont's purchase was more than a whim. It was the result of years of preparation and travel that nurtured his interest in gardens, trees, flowers, and fountains.

Pierre was born in 1870 in a Du Pont Company house overlooking the Brandywine Creek a few miles north of Wilmington, Delaware. His early years were influenced by the area's natural beauty and by the du Pont family traditions of gardening.

Pierre S. du Pont, circa 1912

At the age of nine, he discovered the Mathias W. Baldwin mansion on Chestnut Street in Philadelphia with its conservatory fronting the street. Pierre made an inner resolve that if he ever built a greenhouse it would be kept open to public view from within as well as from without.

The death of father Lammot in a chemical explosion in 1884 had far-reaching consequences: fourteen-year-old Pierre became father to his nine brothers and sisters, providing invaluable training for later accomplishments.

In 1886, he entered M.I.T. near Boston. The highlight of his college years was a three-month trip to Europe in the summer of 1889, where he visited the World's Fair in Paris and also Versailles.

Following graduation in 1890, he secured employment with the Du Pont Company in Wilmington. His mother chose this occasion to build a new house for the family, and Pierre was overseer for the project, which included digging wells and laying out the garden.

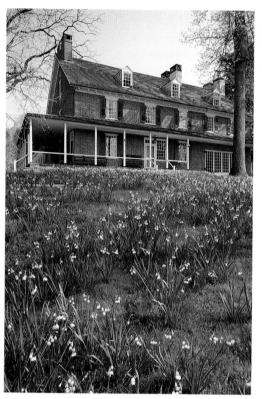

Pierre was 23 when he visited the 1893 World Columbian Exposition in Chicago. He was overwhelmed by the grandiose effects and later recalled that the fountains there were his inspiration for illuminated water at Longwood. Five years later at 28, he acquired a bankrupt florist business. The management of seven commercial greenhouses in Wilmington caused numerous problems over the next six years. Discouraged, he sold the enterprise in 1904.

In 1899, Pierre moved to Ohio and became president of the Johnson Company. Much of his time was spent as a land developer, overseeing the construction of 150 houses with rudimentary landscaping.

In 1904, two years after moving back to Wilmington to again work for the Du Pont Company, Pierre hired a New York firm to landscape 10 acres of undeveloped lawn on the family homestead in Wilmington. The initial survey map they prepared contained too many errors for meticulous Pierre, who noted that "there is not a bit of use in paying you $800 for the privilege of doing the work myself." The bickering continued until 1918, and never again did Pierre use professional garden designers for major landscaping projects. Instead, in 1905 he acquired the first of many gardening

books and thereafter did all his own garden designs.

In July, 1906, Pierre purchased all rights to the historic Peirce's Park and surrounding lands, totaling over 202 acres (today enlarged to 1,050), for approximately $16,000. He had no intention of using the place as a primary residence, and he wasn't planning to build lavish gardens. "I have recently experienced what I would formerly have diagnosed as an attack of insanity; that is, I have purchased a small farm about ten miles from here," he wrote to a friend. However, "I expect to have a good deal of enjoyment in restoring its former condition and making it a place where I can entertain my friends." Pierre later recalled that the real reason for acquiring the farm was to save the collection of old trees.

In 1907, he laid out Longwood's first true flower garden. He filled the 600-foot-long Flower Garden Walk with favorite perennials and biennials, and with some annuals. A pool 20 feet in diameter was constructed at the intersection of the main paths. Its simple jet was Longwood's first fountain.

Although his later gardens would draw heavily on Italian and French forms, this early garden reflected what he termed an "old-fashioned" influence, with nostalgic cottage-garden flowers, exuberant shrubs, rose-laden trellises, picturesque benches, a Peacock Arbor, a birdbath, and even a shiny "gazing ball." The scale was grand, the accessories quaint. From this first axial layout Longwood Gardens has grown, albeit in piecemeal fashion.

The springtime effect of the new Flower Garden was so successful that in 1909 Mr. du Pont hosted a garden party in June. Four hundred people attended and dined on typical garden party fare costing him $1.50 per person. A local infantry band was the musical entertainment, and fireworks provided a fitting climax to a lovely evening. Garden parties were held most years from 1909 until 1916 and from 1919 until 1931, with one last affair in 1940 (which now cost him $3.85 per person for 1,200 guests). These fetes became the highlight of the Wilmington summer social season and no doubt encouraged Pierre to look for ever more wonderful ways to delight his guests.

Peirce-du Pont House

In 1910 and 1913, Pierre and his future wife, Alice Belin, visited Italy. At the Villa d'Este outside Rome, famous for its fountains, he reportedly remarked, "It would be nice to have something like this at home." On the second trip they visited at least 23 villas and gardens, including the Villa Gori in Siena whose outdoor theatre provided the inspiration for one at Longwood. On his return, Pierre had the site of the original Peirce barn excavated, brought in stone to form retaining walls around a 68-foot-wide stage, and planted the wings on either side with hemlock (now arborvitae).

The debut of the theatre at a garden party in June, 1914, was a huge success. A local paper reported that just after dark, electric lights were turned on to illuminate the stage for a series of period dances. The finale was a "frolic by the harlequins, who, much to the surprise of the guests, danced among them, throwing confetti and garden roses, then winding their way out in a path of light, finally disappearing amid the trees." Two weeks after this tremendously successful party, Pierre began experimenting with fountains for the theatre stage, which first gushed at the 1915 garden party.

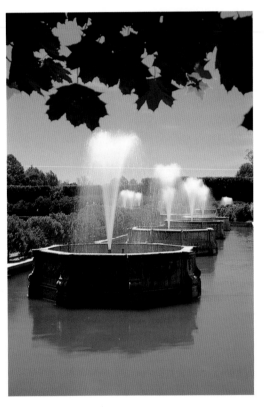

Longwood in the early years was enchanting during warm weather but, Pierre noted, "rather dreary in winter" with visitors "few and far between." Perhaps this is why in 1914 he built an L-shaped extension onto the original Peirce farmhouse. Connecting the old and new wings was a conservatory, Longwood's first. This courtyard is luxuriously planted with exotic foliage and is graced with a small marble fountain, a wedding present to mark Pierre's marriage in 1915 to Alice Belin.

He must have been pleased because he was soon contemplating much larger facilities "designed to exploit the sentiments and ideas associated with plants and flowers in a large way." The huge Conservatory was designed by J. Walter Cope (1884-1973) and officially opened on November 25, 1921. The main building is 181 feet wide by 204 feet deep, shaped into a "T" with a 25-foot-tall colonnade around the interior edge; the ridge of the central roof rises about 40 feet. Adjoining the main hall (which was planted with oranges) are ranges originally used to grow azaleas, figs, grapes, melons, nectarines, peaches, pineapples, roses, and flowering plants. It would be hard to imagine a more theatrical setting for the indoor display of plants.

At the same time, the rolling countryside in front of the Conservatory was transformed into the formal groundwork for Longwood's Main Fountain Garden. One-hundred-five Norway maples were planted in allée fashion on the far three sides of a 300 by 480-foot rectangle. Boxwoods were planted along the fourth side closest to the Conservatory. From this simple design the entire fountain garden would evolve a decade later, although there is no indication that Mr. du Pont was planning for it at the time; in fact, Longwood did not yet have any major fountains.

The 1920s brought extraordinary creativity to the property. In 1921, a 3,650-pipe Aeolian organ was installed in the new Conservatory. In 1923, an elegant Music Room was designed by J. Walter Cope opening onto the central axis of the main greenhouse, with walnut panelling, damask-covered walls, teak floors, and a molded plaster ceiling in the most refined drawing room tradition. In 1928, a huge Azalea House designed by E. William Martin was added to the east. A year later, Martin created a 103-foot-long by 35-foot-wide Ballroom, resplendent with a pink etched glass ceiling, crystal chandeliers, and a walnut parquet floor from surplus World War I gunstock block. The original organ was replaced with a specially commissioned 10,010-pipe Aeolian instrument hidden behind fabric walls along the north side of the room.

In the mid-1920s Pierre turned away somewhat from corporate matters to spend more time on philanthropic and personal interests. The summer of 1925 was capped by a trip to France and a two-week tour of 50 chateaux and gardens, including a visit to Monet's garden hosted by the painter himself. It was at this time that Pierre began construction of the Italian Water Garden in a low-lying, marshy site northeast of Longwood's Large Lake. He chose for inspiration not a French garden, however, but the Villa Gamberaia, near Florence, Italy, which he had visited in 1913. He probably based his plan on one published in a garden book, and he took into

Upper Canal in Main Fountain Garden

account visual foreshortening by making the farther pair of rectangular pools 14 feet longer than the nearer pair. This ensures that all four pools appear proportionately equal when viewed from the elevated observation terrace.

The Italian original has only a few fountains, but in Longwood's Water Garden more than 600 jets in nine separate displays shoot from six blue-tiled pools and from twelve pedestal basins along the sides. Pierre filled about 50 pages with handwritten calculations to figure out the hydraulic requirements. At maximum capacity 4,500 gallons per minute are recirculated, with the tallest jet in the far pool 40 feet high. A surprise feature is a curving water staircase to the southwest which complements a traditional staircase to the southeast. The arched wall that connects them and supports the observation terrace is embellished with sculptured fountains and terra cotta jars.

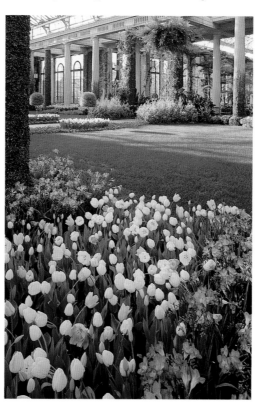

The garden was planted with lindens along both sides and with evergreens at the far end; English ivy borders the pools. Limestone copings, pedestal basins, and ornaments carved domestically and in Italy add a distinctively Italian flavor. In its setting within a wooded clearing and in concentration of jets, however, the garden resembles more a fanciful water bosquet at Versailles. Its full beauty is revealed only by walking down into the garden to see the backlit water shimmering against the deep green foliage.

Pierre also decided to enlarge the Open Air Theatre. It had been used since 1914 for theatrical performances, garden parties, concerts, and as a place of amusement for Mr. du Pont's nieces and nephews. The grassy seating area was flat, which restricted visibility, so in 1926 the area under the stage was excavated and spacious underground dressing rooms were built. The soil that was removed was used to give the proper slope to the auditorium.

A new, much enlarged fountain system was installed, with seven circular basins with removable covers built into the main stage floor, a unique six foot-high water curtain, two upper level basins, and isolated roof fountains off to either side. Beneath the stage are 11 pumps recirculating 2,000 gallons of water per minute through 750 nozzles.

These are illuminated from below by over 600 lights in red, blue, green, white, and—added in 1933—yellow. The jets and lights were originally controlled from a hand-operated switchboard in the spotlight tower behind the audience.

Nothing like this had ever before been seen! Describing a 1928 public showing, the newspapers noted that the new fountains were "like fireworks, rockets upside down, or weird deep-sea mysteries of coral and fan-shaped fungus, colored in turn ghostly violet or flaming gold, fiery scarlet, yellow, blue and green." Even today they are unique. The color is intense, and the introduction of compressed air into the jets at the end of a display produces a thrilling and unexpected finale as the fountains are rocketed 50 feet up into the trees.

Mr. du Pont was inspired by the success of the Italian Water Garden and the Theatre to create the ultimate fountain display to rival that which he had seen at the Chicago Fair 35 years before. The area directly south of the Conservatory had been planted in 1921 with boxwood and a U-shaped allée of Norway maples. To this he added, beginning in 1928, two long canals and two circular pools in the area bounded by the maples, and a huge rectangular basin on the far hill. The pools and basins are filled with 380 fountainheads, scuppers, and spouts. A recirculation system of 18 pumps propels as much as 10,000 gallons of water a minute as high as 130 feet. Adjoining reservoirs supply a 50-foot mini-Niagara cascading next to a French-inspired Chimes Tower. The entire system holds 675,000 gallons of water.

The Main Fountains were first turned on in 1931, but it was several years before the five-acre garden was finished. Tons of limestone carved into decorative flowers, fruit, and water creatures were shipped from Italy by the Florentine firm Olivotti to impart an Old World feeling. To give a green background, Pierre turned the adjoining cornfield into an instant landscape with several hundred mature trees and shrubs, some as high as 70 feet tall. These were transplanted from estates, nurseries, and from the wild throughout 14 states by Lewis and Valentine, the country's foremost tree movers.

Orangery in February

The stonework and plantings, magnificent by day, are rendered invisible at night when the fountains assume a new dimension. Six-hundred-seventy-four lighting units with colored glass filters tint the water red, blue, green, yellow, and white, with every conceivable variation in between. The spectacle is managed from a small room beneath the observation terrace in front of the Conservatory. The original control board had more than 200 toggle switches and 100 small levers to activate the pumping and dimming equipment located in the pump house at the opposite end of the garden. This system was replaced in 1965 with a modern theatre lighting board, but it was not until 1984 when the system was computerized and synchronized to music that its true artistic potential could be realized.

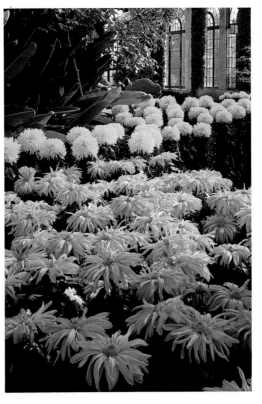

From the point of view of garden history, the Main Fountain Garden is an eclectic assemblage of Italianate ornamentation and French grandeur, with a heavy dose of World's Fair showmanship. Its theatricality is dazzling.

The completion of the fountains in the mid-1930s marked an end to major construction during Mr. du Pont's lifetime, although he built a 30 by 36-foot oval analemmatic sundial in what is now the Topiary Garden in the late 1930s, with a new Rose Garden nearby.

As early as 1914 with the formation of Longwood, Inc., Pierre was thinking about the eventual fate of the property after his death. In 1937, the Longwood Foundation was created to handle his charitable giving. In 1944, Mrs. du Pont died, and he was more concerned than ever about Longwood's future, particularly since he had no children but considered the Gardens part of the du Pont family legacy. The government gave approval in 1946 for the Foundation to operate Longwood Gardens "for the sole use of the public for purposes of exhibition, instruction, education and enjoyment." When Pierre died in 1954 at the age of 84, he left Longwood with a well-established horticultural tradition, experienced businessmen (his nephews) as trustees, and a sizeable endowment.

Enormous effort and funds have since been expended to convert Longwood into a garden with maximum public appeal while retaining the dramatic charm of Mr. du Pont's creation. Greenhouse areas used to grow fruits and vegetables were replaced with horticultural displays beginning in 1955. A picnic area and plant nursery were established in 1956, the same year that an orientation center opened and guide maps were printed. A Desert House and 13 outdoor waterlily pools were constructed in 1957. New greenhouses devoted to tropicals opened in 1958. A plant breeding program was initiated in 1960, and, two years later, a new Visitor Center with a shop, auditorium, and 1,000-car parking lot on the former golf course gave evidence of a major commitment to the public.

Greenhouse production facilities were expanded in 1963, and in 1966 a large Palm House opened. From 1969 to 1973, the 1928 Azalea House was replaced with a clear-span structure now known as the East Conservatory. The Peirce-du Pont House was opened to the public in 1976, and the Visitor Center was greatly expanded in 1979. A 400-seat restaurant opening in 1983 was the last major building to be constructed in the public areas.

Mr. du Pont dictated Longwood's aesthetic approach during his lifetime, aided by Mrs. du Pont and, no doubt, in later years by the head gardeners. Professional management was instituted in 1955, and some du Pont family members felt that although the Gardens were growing beautiful plants, the displays were a patchwork. To address this situation the Trustees established in 1958 an Advisory Committee of five du Pont family women and men to help with aesthetic matters. One of the original participants was Pierre's second cousin Henry Francis du Pont, of Winterthur fame. A Landscape Committee was formed in 1970, and the noted landscape architect Thomas Church served on it. He designed the Theatre Garden (opened 1975), the Wisteria Garden (1976), and the Peony Garden (1976) to replace flower gardens dating from 1908. Sir Peter Shepheard succeeded Church in 1977 as consulting landscape architect, and his biggest project to date has been to redesign the 1957 waterlily pools (opened 1989).

Local and regional landscape architects created indoor "Example Gardens" from 1973 to 1985 as well as parts of the outdoor Idea Garden devoted to

Orangery in November

the latest in annuals, perennials, ground covers, grasses, roses, vines, herbs, berries, tree fruits, and vegetables. An indoor Children's Garden opened in 1987 and was redesigned in 1990. Garden architect Isabelle Greene created the Silver Garden (1989), Roberto Burle Marx and Conrad Hamerman produced the tropical Cascade Garden (1992), and Ron Lutsko designed the Mediterranean Garden (1993).

The Advisory and Landscape Committees were involved in all these projects, with joint members and invited professionals meeting regularly with the staff to critique existing displays, approve ideas and changes, and suggest new approaches. This ensures that all possible concerns, from historic preservation to horticultural and aesthetic excellence to practical maintenance, are considered. The result is a constantly evolving garden.

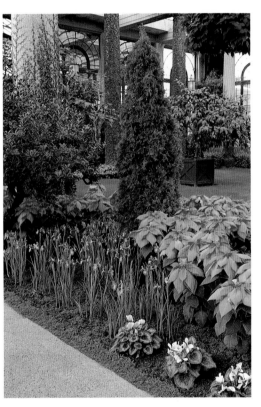

Resources have also been devoted to scientific research, plant identification, and plant exploration. Most of the research effort goes into new crops, plant improvement, and cultural studies of plants grown for public display. A continuing effort identifies, labels, and maps 11,500 computerized plant accessions. From 1956 to 1971, Longwood sponsored a series of 13 plant exploration trips in conjunction with the United States Department of Agriculture to far-flung destinations throughout the world; trips resumed in 1984. The best plants collected may eventually find their way into commercial horticulture, such as the popular New Guinea impatiens.

Longwood's foremost influence on American horticulture has been through its educational programs, in keeping with Mr. du Pont's desire to establish "a school'where students and others may receive instruction in the arts of horticulture and floriculture." For the past three decades, as many as 5,000 students a year have attended Continuing Education classes designed for both amateur and professional gardeners and nurserymen. In addition, since 1958 some 1,000 students from all over the world have participated in one or more of seven intensive programs, ranging from internships to a two-year professional gardener training program to a master's degree program in public horticultural administration. Graduates have gone on to leadership roles in many of the country's top horticultural institutions.

Longwood's extensive performing arts program is a logical outgrowth of Pierre du Pont's interest in music and theatre and takes advantage of the many performance spaces he created. More than 400 events are scheduled each year, ranging from Ballroom organ concerts to outdoor folk and chamber music to Open Air Theatre productions with more than 100 people on stage and an audience of 2,100. Seasonal festivals offer ample opportunities for all types of activities. Winter Fun Days and summer Ice Cream Concerts are designed for children, who also delight in November's stuffed topiaries. Spectacular fireworks and fountain displays attract as many as 5,000 spectators on summer evenings, and nearly 200,000 visitors come to see 400,000 lights outdoors at Christmas.

Renovation is a key word at Longwood during the 1990s. Aging structural and mechanical systems are now being replaced. The 1925 Italian Water Garden was completely rebuilt from 1990 to 1992 at a cost of more than $4 million. The restoration of the Conservatory and Main Fountain Garden will soon follow. Tens of millions will have been spent by the year 2005 on physical plant restoration. Yearly operating expenses are more than $20 million, and the staff includes 166 full-time employees and 300 part-time workers, students, and volunteers. Longwood is able to offset half its operating expenses from admissions, garden shop sales, education programs, rentals, and restaurant income; Mr. du Pont's legacy funds the rest.

Fortunately, the public has embraced Longwood Gardens with great enthusiasm. Longwood's early heritage is rich, and its modern-day additions exemplify the finest in contemporary horticulture. Yet much of its public appeal is due to Pierre du Pont's innate sense of the garden as theatre, and this ties Longwood directly to the great gardens of Italy and France, and to the spectacular 19th-century world's fairs that proclaimed the triumph of technology. Longwood combines gardening arts with technology, and the results are unforgettable.

Orangery in December

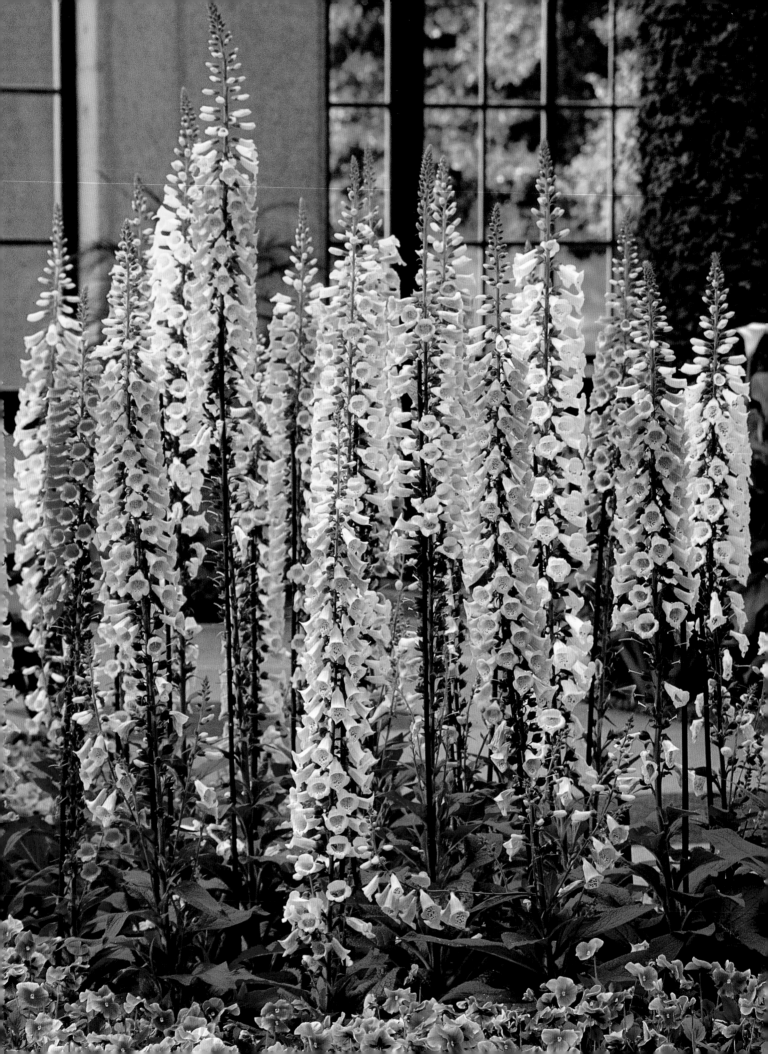

WELCOME SPRING INDOORS

At no time is Longwood Gardens more breathtaking than from January through April. Outdoors it may be snowing, but inside Longwood's Conservatory, spring is perpetual. Some 4,500 types of plants thrive in 20 gardens set within nearly four acres of greenhouses. Exotic specimens abound, and visitors can tour the globe from tropics to desert. The fragrance alone—citrus, daphne, roses, violets—entices one to linger.

Especially memorable are the Orangery, originally planted with orange trees but now filled with everblooming flower beds beside manicured lawns; the adjacent Exhibition Hall, graced with stately tree ferns and used occasionally for dinners, dancing, concerts, and flower shows; and the East Conservatory, a great honeycombed structure housing towering palms and sinuous pools.

Pierre du Pont went to great lengths to minimize the greenhouse look and to impart architectural elegance to these buildings. The arched windows are made of bronze, and a large colonnade hides the structural steel while giving a pleasing spatial rhythm. Creeping fig covers many of the tall pillars, which resemble massive tree trunks. The mechanical systems are hidden in underground tunnels, and when the greenhouses are illuminated at night the roof structure all but disappears.

The horticultural year begins in January and February with feathery acacias in gold and lemony hues. By late March hundreds of cymbidium orchids suffuse the borders with pastels. April's Easter lilies provide stately bloom as the outdoor gardens and fountains come to life with renewed vigor. Among plants flowering in the greenhouses are African-violets, azaleas, begonias, bougainvilleas, camellias, cinerarias, crabapples, delphiniums, euryops, genistas, hibiscus, orchids, pansies, primroses, and rhododendrons. A wealth of 50,000 spring bulbs includes amaryllis, daffodils, freesias, fritillarias, hyacinths, lilies, muscari, scillas, and tulips, all of which bloom at some time between January and April.

It takes considerable skill to manage what is no doubt the nation's largest continual indoor flower show. This task falls to the Horticulture Department, one of Longwood's major operational divisions. The indoor gardens are in the hands of two foremen and 20 gardeners to oversee production and display.

The collective experience of decades has gone into perfecting the effect, not only in knowing how to grow the best specimens but also in having the plants bloom at the right time. Seeds, bulbs, and rooted cuttings or young plants are ordered up to a year ahead. The design process has to be flexible, due to variables of crop growth and weather. Plants near the peak of bloom from the production houses are plunged into the display beds to replace fading specimens. Special care is taken to note outstanding color combinations that can be incorporated into next year's design. The result is a cross between Victorian carpet bedding and the English perennial border.

Providing a favorable round-the-clock climate is the responsibility of at least nine specialists in the Maintenance Department, who fire up three boilers capable of heating 500 homes and who keep thousands of feet of steam line in operation. To heat the greenhouses for a year requires oil and gas totalling the equivalent of 150,000 gallons of fuel.

Welcome Spring offers more than flowers. It encompasses Mr. du Pont's idea of the garden setting for a variety of activities, even in winter. Sunday afternoon organ or piano concerts in the Ballroom, children's programs, and non-profit nighttime fundraisers for charity fill the Conservatory with varied events made all the more pleasant by the springtime setting. Serious students of horticulture can attend Continuing Education classes and use Longwood's specialized reference library. Its 20,000 volumes include not only Mr. du Pont's garden books but also the latest publications on botany, horticulture, landscape design, and garden history. Opportunities to learn abound.

And so with Welcome Spring, Longwood conquers winter's chill with cheerful color, subtle fragrance, and a gentle warmth that preview the extravagance of bloom that will soon follow outdoors.

Opposite: Foxgloves indoors in May *Above:* Ranunculus in March

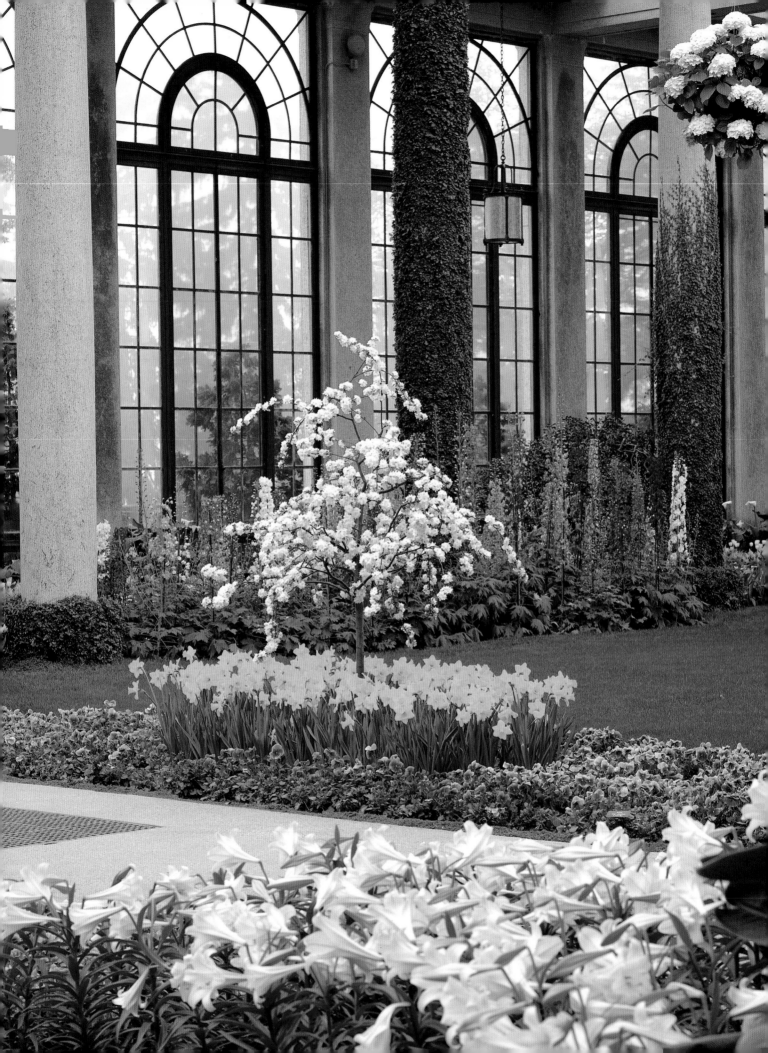

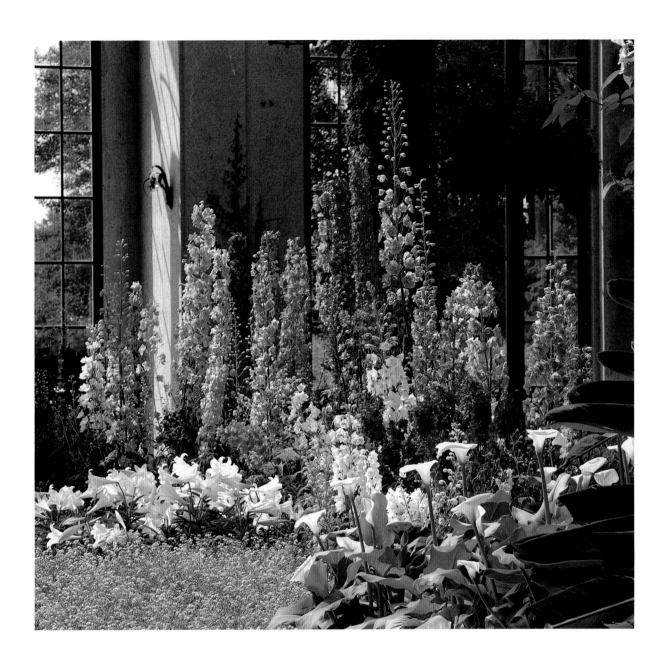

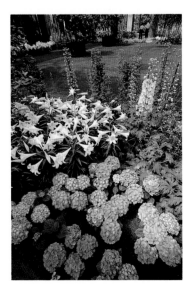

Opposite: Flowering crabapple, daffodils, pansies in Orangery *Above:* Towering delphiniums in April
Below: Hydrangeas, Easter lilies, delphiniums *Overleaf:* Cymbidium orchids, echiums, Madeira geraniums in East Conservatory

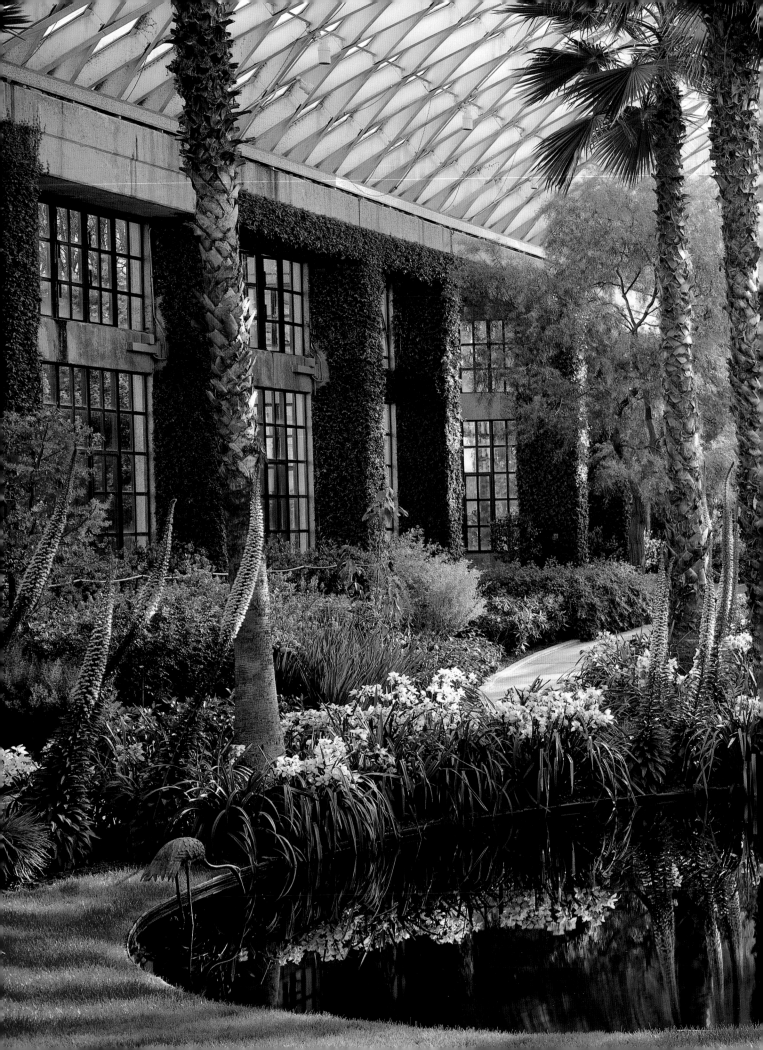

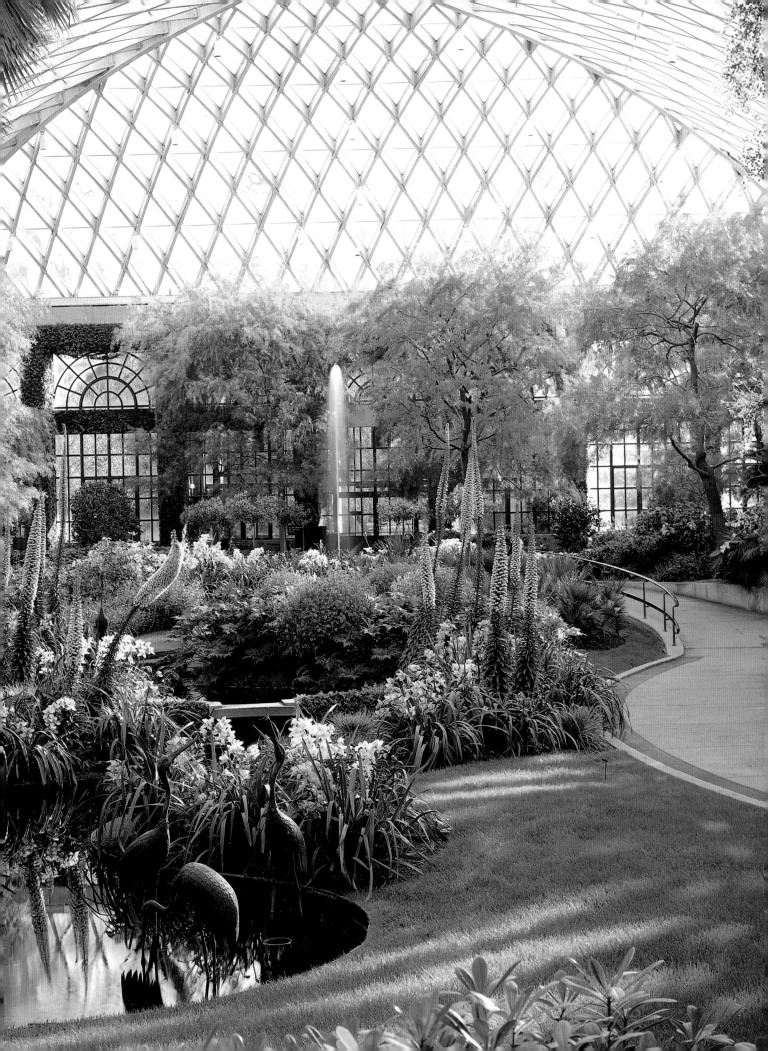

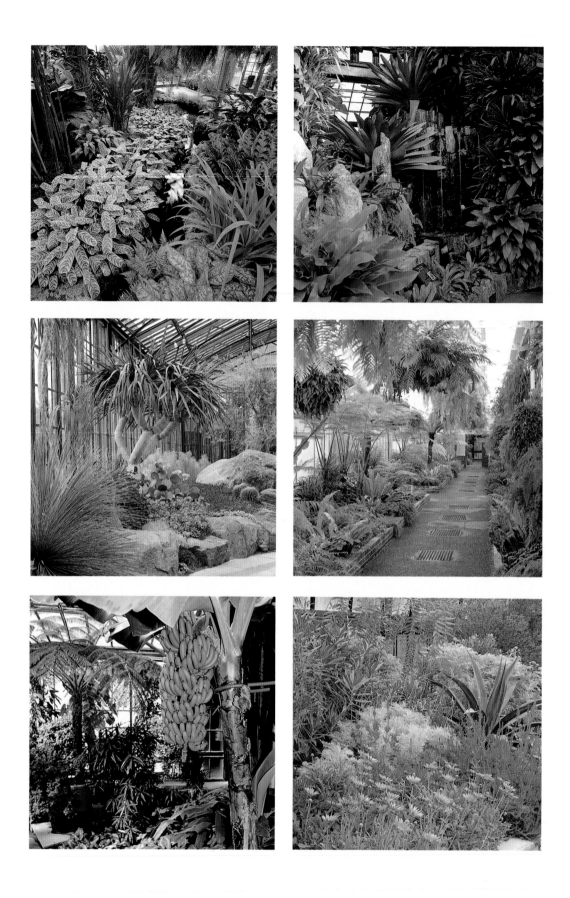

Tropical Terrace
Silver Garden
Tropical Terrace bananas

Cascade Garden
Fern Passage
Mediterranean Garden

Opposite: Yellow acacias, orange clivias in January

14

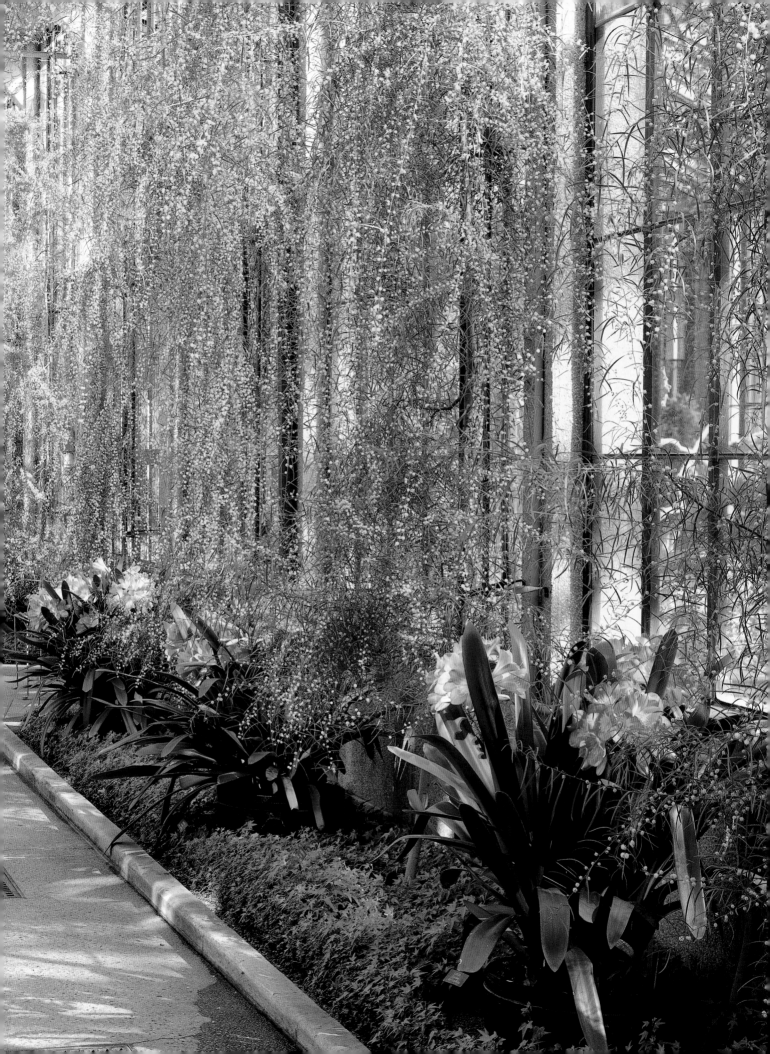

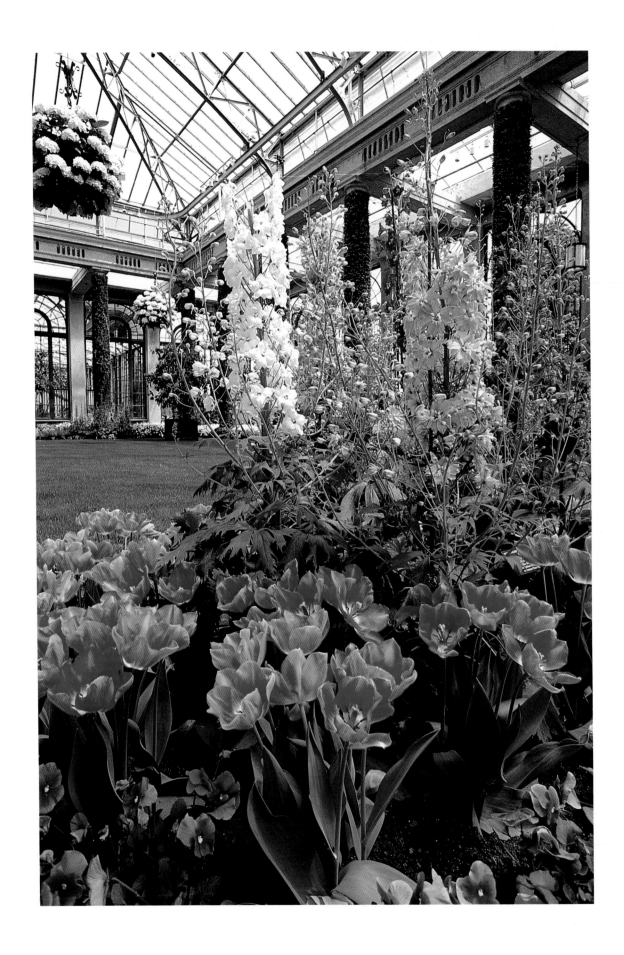

Pansies, tulips, delphiniums in Orangery in April

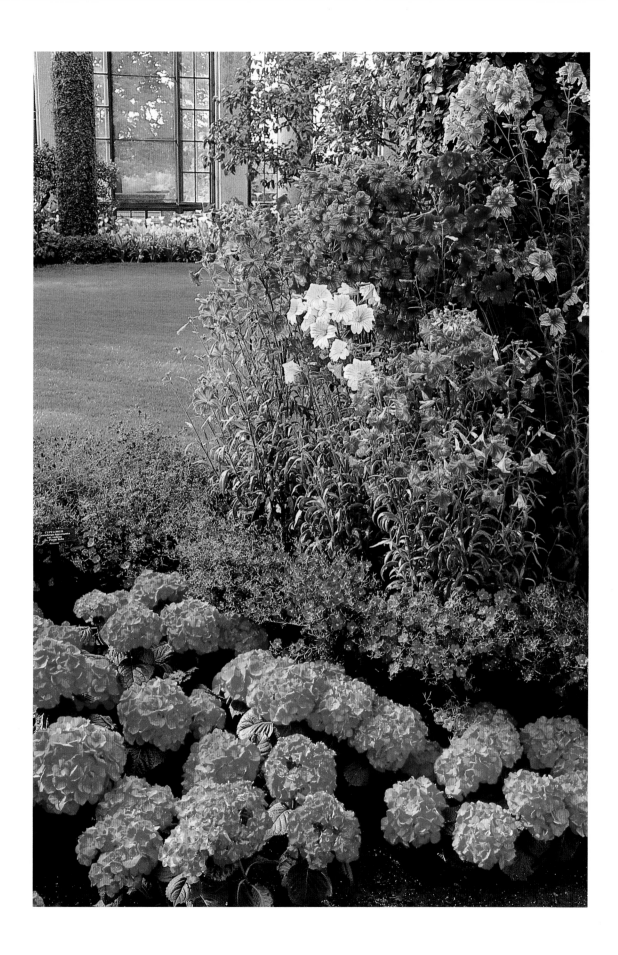

Hydrangeas, nierembergias, multicolored salpiglossis

17

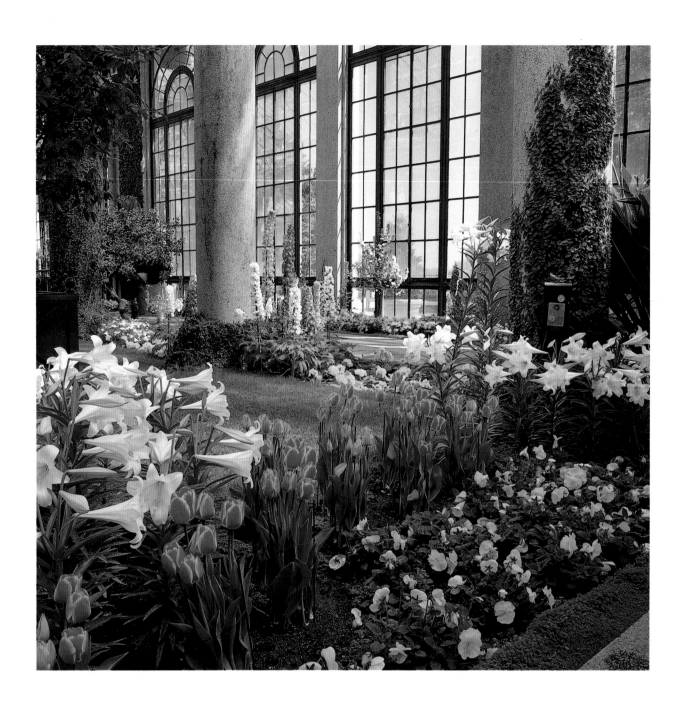

Orangery at Eastertime

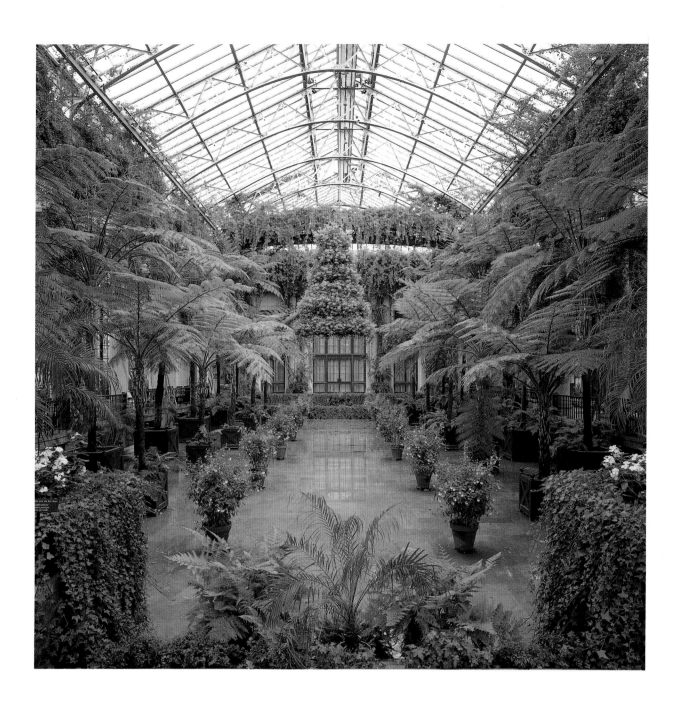

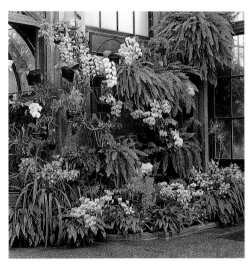

Above: Exhibition Hall with bougainvillea, tree ferns, ivy geranium chandelier *Below:* Orchid Display

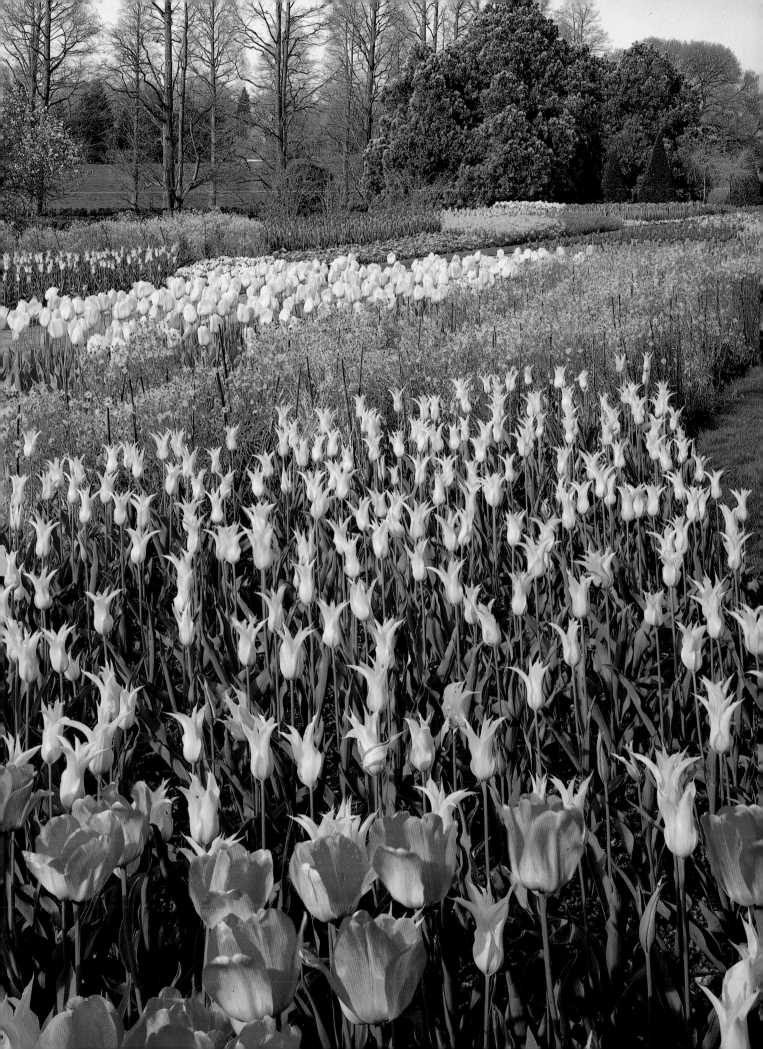

ACRES OF SPRING

With so much color in Longwood's Conservatory, it's easy to overlook an occasional hint of spring outdoors as the new year unfolds. Yet as early as January the perceptive visitor may find sights to gladden the winter-weary soul. A few days of mild weather and the Chinese witch-hazel and its hybrids are glowing with yellow, orange, or reddish hues and spicy scent.

By late February and into early March, tiny white snowdrops, the larger white snowflakes, blue and white squills and chionodoxas, and creamy white to pink to wine red lenten-roses make their appearances. Yellow winter-aconites and adonises, blue and purple dwarf irises, and brightly hued crocuses are even more conspicuous. These gems, true harbingers of spring, are tucked away in sunny corners of the Hillside Garden and scattered in drifts throughout the lawns.

The full force of the new season has overtaken the outdoor gardens by early April. Lawns green up virtually overnight, daffodils open by the tens of thousands, and magnolias, forsythias, and flowering cherries provide the first large-scale color and fragrance. Early magnolias present a special challenge because of the hazards of frost, but when the weather cooperates the hundreds of blooms are breathtaking.

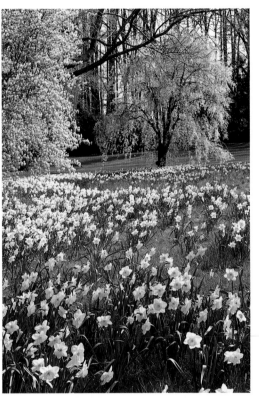

Majestic trees abound, since the property was one of the country's first arboretums. Nineteenth-century bald-cypresses, beeches, cedars, cucumber trees, firs, ginkgos, hemlocks, horse-chestnuts, junipers, larches, maples, oaks, pines, spruces, and tulip trees form a stately backdrop. Those that are deciduous leaf out into a patchwork of soft greens, red, and coppers. Twentieth-century azaleas, cherries, crabapples, dogwoods, lilacs, magnolias, paulownias, redbuds, rhododendrons, and viburnums fill the arboreal superstructure with color and fragrance.

Longwood's Hillside Garden is a continuing surprise from March through June. After the minor bulbs come Korean azaleas, species tulips, and bluebells, then lilies-of-the-valley, pink creeping phloxes, white candytufts, and yellow alyssums.

Dozens of less familiar rock garden plants, from cyclamens and miniature narcissi to primulas and trout-lilies, thrive in this rugged area pocketed with microclimates.

The Wisteria and Peony Gardens bloom in May with Impressionistic intensity. The lavender or white blossoms from a half dozen cultivars of wisteria engulf a tall arbor as well as multi-tiered tree standards. The tree peonies share the spotlight with Siberian irises and golden-chain trees.

Particularly imposing is an avenue of stately paulownias, or princess trees, leading from the Visitor Center to the Conservatory. In May, showy upright clusters of blossoms crown the landscape with a purple haze.

Tulips along the Flower Garden Walk in late April and early May and native azaleas in the woods beginning in mid-May bring spring to its peak. In all, 6,500 different types of plants are grown outdoors in the Gardens, and many put on their best show at some time from late March through mid-June.

Longwood's 20 major outdoor areas as well as the surrounding perimeter are overseen by two horticultural foremen. Fourteen gardeners tend the flower gardens and areas of concentrated horticulture and oversee a nursery for future plant needs. Thirteen groundskeepers groom the turf and move full-grown trees. Six arborists care for the thousands of trees. Extra assistance is provided by seasonal workers, volunteers, and Longwood's students, who receive invaluable hands-on training working alongside professional horticulturists. Their combined efforts permit the meticulous maintenance and attention to detail that have been a hallmark of the gardens since Pierre du Pont's time.

Spring outdoors has a special significance for Longwood's history. The beauty of the place in June inspired Mr. and Mrs. du Pont to host annual garden parties. These in turn became the perfect occasions to introduce—and perhaps catalysts to build—a myriad of garden pleasures created from 1913 until the early 1930s, including the Open Air Theatre, the Conservatory, and the fountains.

Opposite: Flower Garden Walk in late April *Above*: Daffodils and weeping Higan cherry by Large Lake

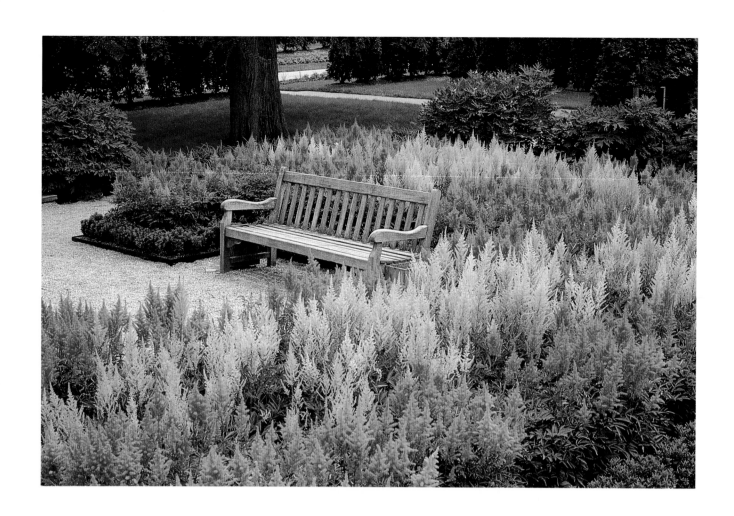

Above: Astilbes in June *Below:* Rhododendrons below Chimes Tower in May

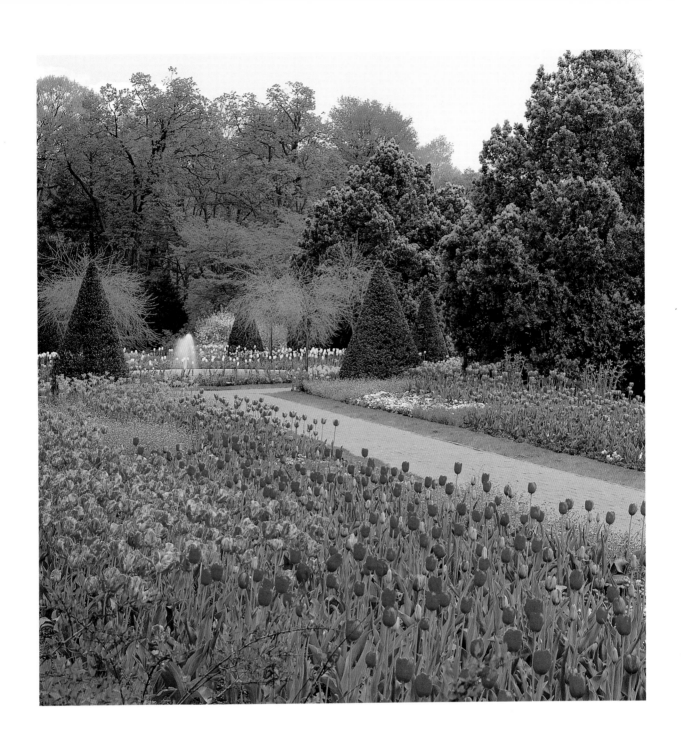

Flower Garden Walk *Overleaf:* A sea of tulips in May

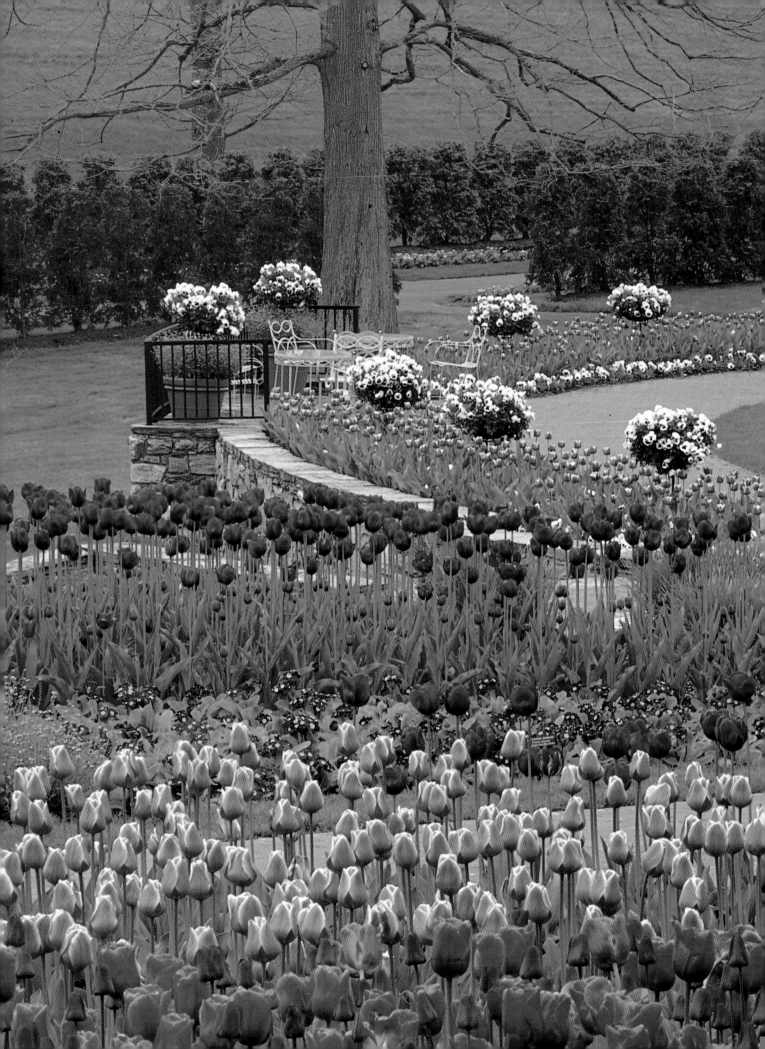

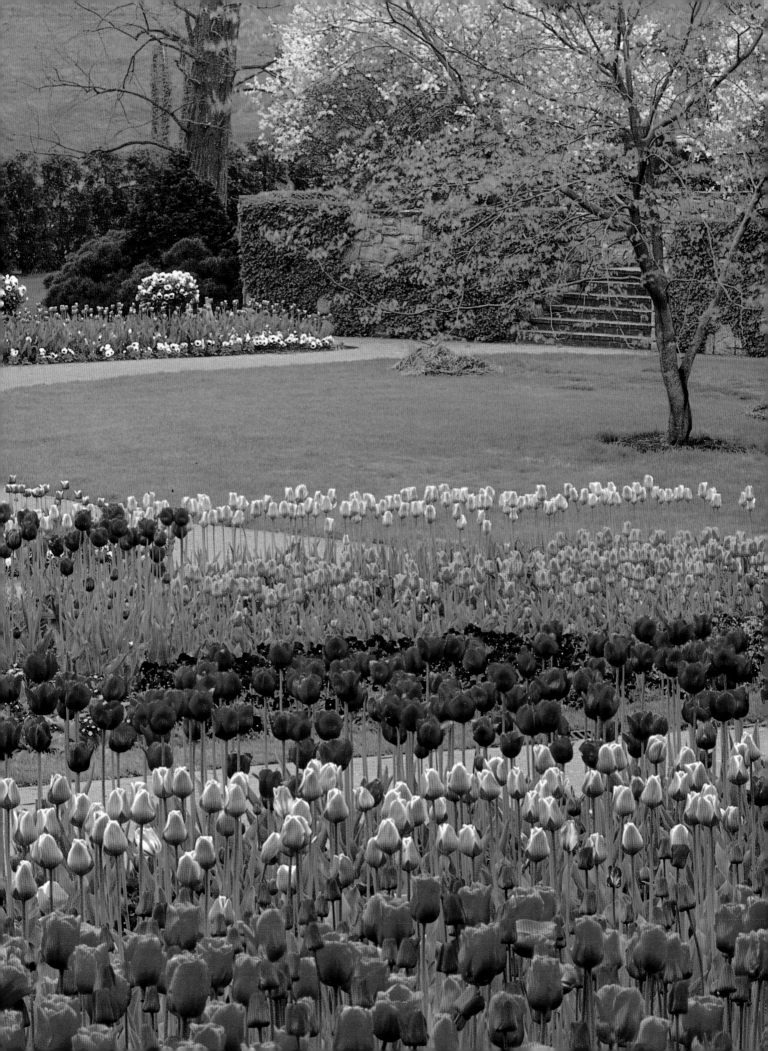

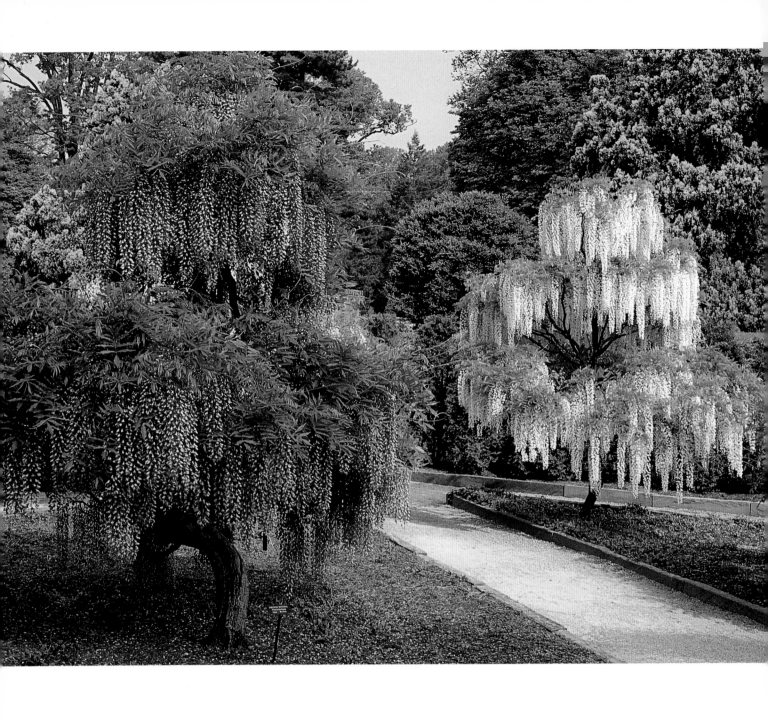

Wisteria Garden in May

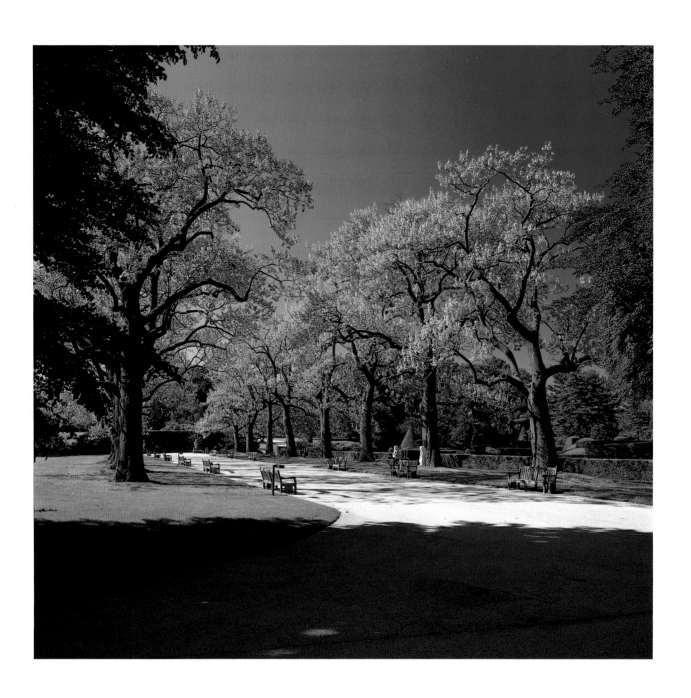

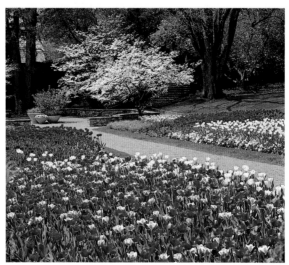

Above: Paulownias in May *Below:* Tulips with flowering dogwoods

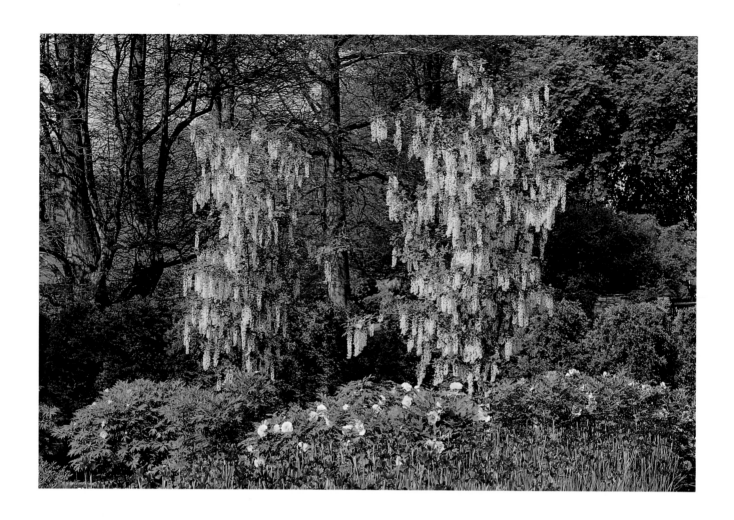

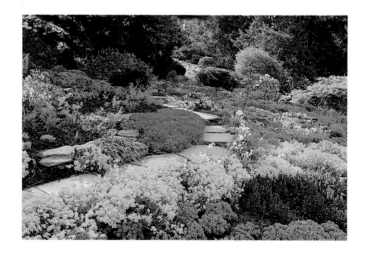

Above: Golden-chain trees, tree peonies, Siberian irises in May *Below:* Yellow alyssum, pink moss phlox in Hillside Garden

28

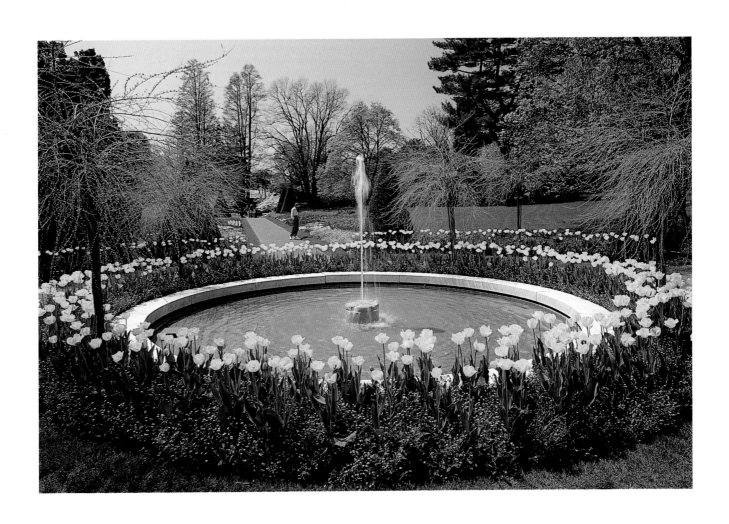

Round Fountain encircled by tulips and forget-me-nots

29

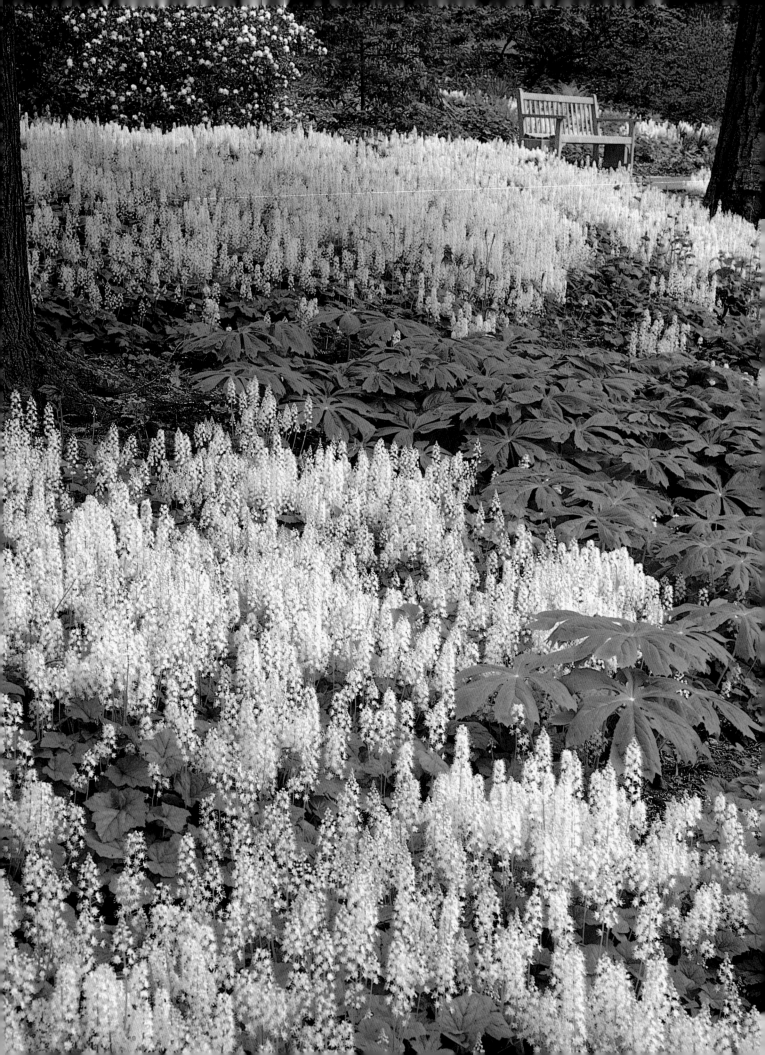

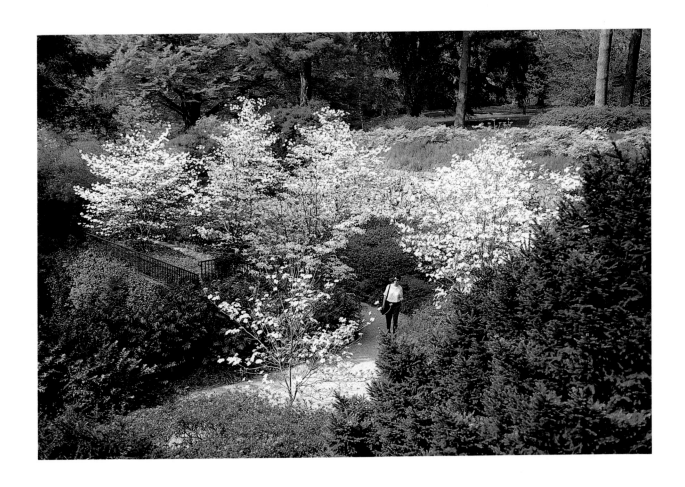

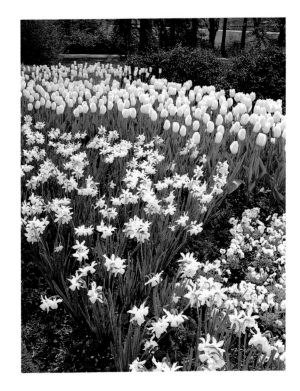

Opposite: Foam flowers, May-apples in Peirce's Woods
Above: Flowering dogwoods near Waterfall in May *Below:* Daffodils, tulips, white and purple pansies

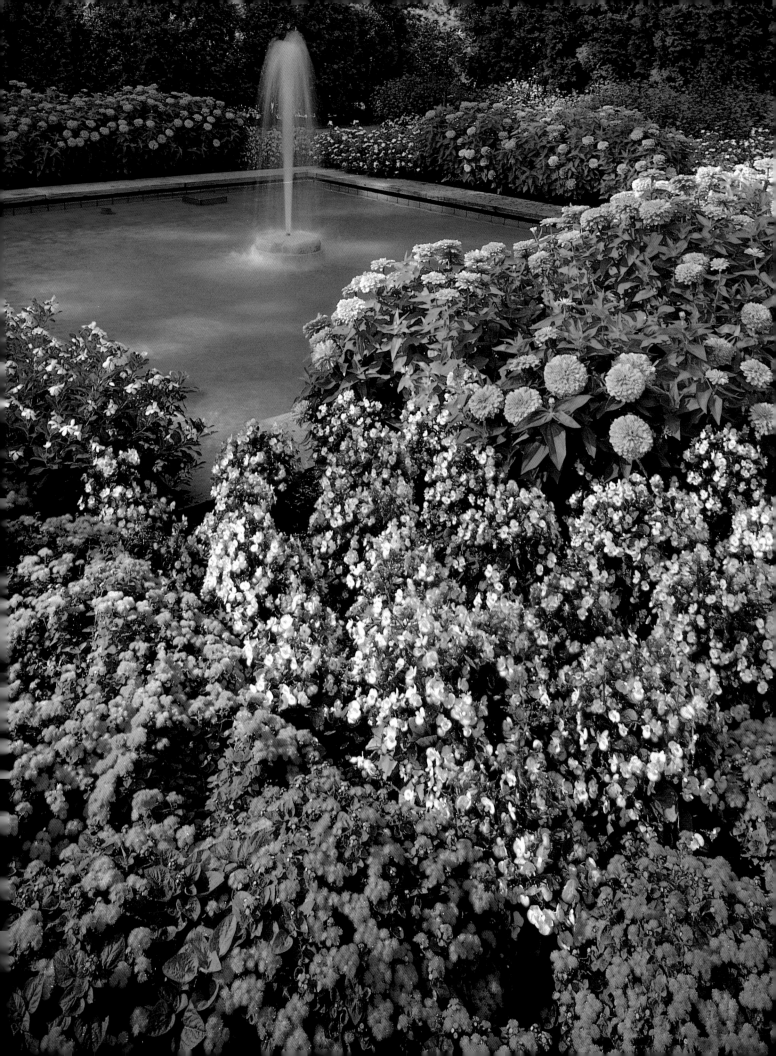

Festival of Fountains

Longwood as a pleasure garden where horticulture, architecture, theatre, and music thrive is especially appealing during the Festival of Fountains from June through September. Luxuriant gardens, splashing jets, and leafy glades encourage quiet contemplation by day; at night, alfresco concerts, illuminated fountains, and, on special occasions, scintillating fireworks create garden magic.

Most magical of all are Longwood's waterworks. Not since the 18th century have so many fountains graced a garden, for Pierre du Pont had both the means and the creative abilities to indulge in his wildest hydraulic fantasies.

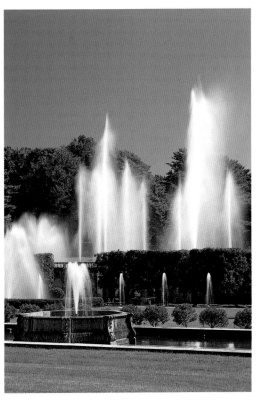

Longwood's first fountain was a single jet built in 1907 in the Flower Garden Walk. In 1914, simple fountains were added to the stage of the Open Air Theatre; this display was redesigned in 1926-27, with color lighting for after-dark effect. The Italian Water Garden was constructed from 1925-27, along with a pool and five jets at the eastern end of the central allée in Peirce's Park. By 1928, Pierre and his master electrician, Russell Brewer, had learned enough through trial and error to create the Main Fountain Garden from 1928-31, with carvings and landscaping added until the mid-1930s. In all, these separate fountain systems have more than 1,700 jets rising as high as 130 feet and recirculating nearly 17,000 gallons of water a minute. The fountains run daily from Easter to mid-October, with special five-minute full-capacity displays alternating on the hour between the Open Air Theatre and the Main Fountain Garden.

The Theatre is also the site for many outdoor performing arts events during the summer. As many as 2,100 spectators enjoy concerts, dance, operetta, and Broadway musical revivals presented in its sylvan setting. A short display of the colored stage fountains concludes many performances.

It is the illuminated displays of the Main Fountains that visitors from around the world come to see. From 1931 to 1979, the shows were accompanied only by the sound of splashing water (and sometimes chimes), but in 1980 music was added. Computerized controls installed in 1984 permit split-second synchronization, down to individual drum beats or cymbal crashes. It is theoretically possible to execute at least 17,300,000 jet and color changes during a half-hour evening show! Inasmuch as Longwood is an engineer's garden filled with all the technological wonders of the time, Mr. du Pont would no doubt approve of these latest innovations.

Most thrilling of all are the occasional fireworks spectaculars, first presented in 1980. These monumental tableaux of fire and water are so popular that admission is by advance ticket sale only. Four to five thousand spectators attend each show.

One summer attraction that is very popular but needs no advance reservation is the outdoor waterlily display, at its best from July through September. Thirteen waterlily pools were constructed in 1957 and rebuilt as five pools in 1988-89. They are filled with more than 70 types of day and night-blooming tropical waterlilies, hardy day-bloomers, lotus, and miscellaneous aquatic plants. Of special interest are the giant waterplatters with seven-foot-wide rimmed leaves first hybridized at the Gardens in 1960 by crossing *Victoria cruziana* with *Victoria amazonica*. The leaves often grow 3 to 6 inches daily, weigh up to 10 pounds, and can support upwards of 150 pounds apiece before collapsing.

Other summer delights include the Rose and Topiary Gardens with scented bloom and the precision geometry of clipped yew, the Flower Garden Walk overflowing with annuals, placid lakes with English-style vistas, and the deep calm of forest paths. For home gardeners, the Idea Garden has the latest in annuals, perennials, ground covers, roses, vines, herbs, berries, tree fruits, and vegetables.

Longwood's Festival of Fountains utilizes Pierre du Pont's creation to its fullest. As with the gardens of Italy and France, the landscape becomes an outdoor room for celebration, and the effect is completed by the thousands of visitors who come to enjoy and be a part of the show.

Opposite: Ageratum, begonias, zinnias, Madagascar periwinkle bordering Square Fountain *Above:* Main Fountain Garden

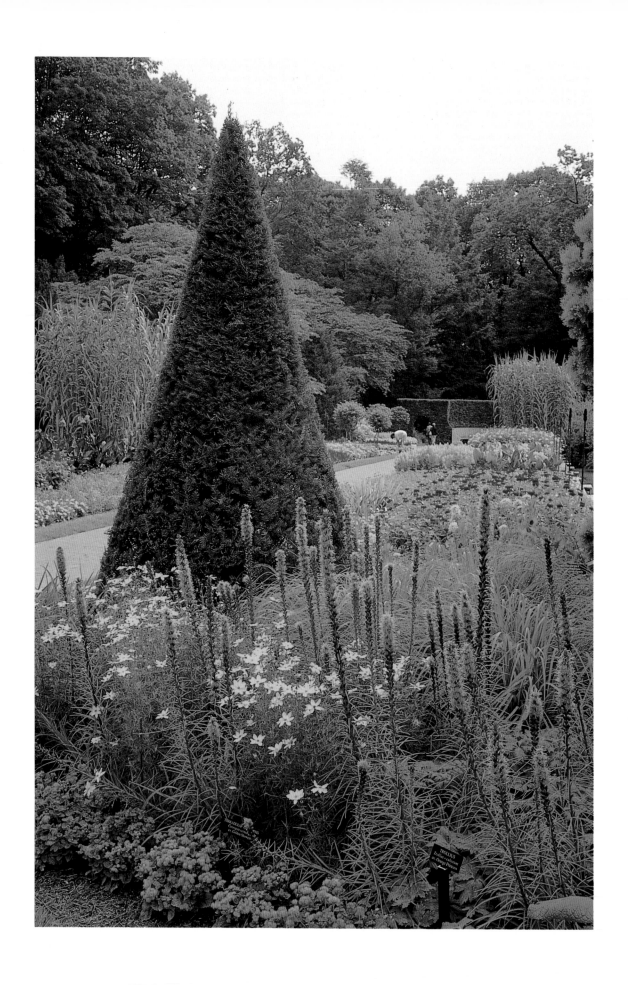

Ageratum, coreopsis, liatris along Flower Garden Walk in July

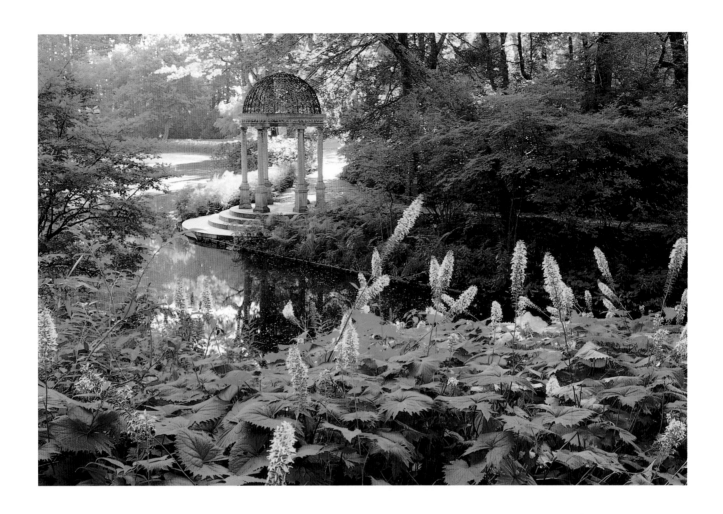

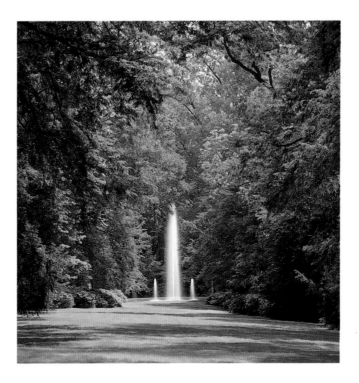

Above: Ligularias bordering Large Lake *Below:* Sylvan Fountain shooting up 40 feet in Peirce's Park

35

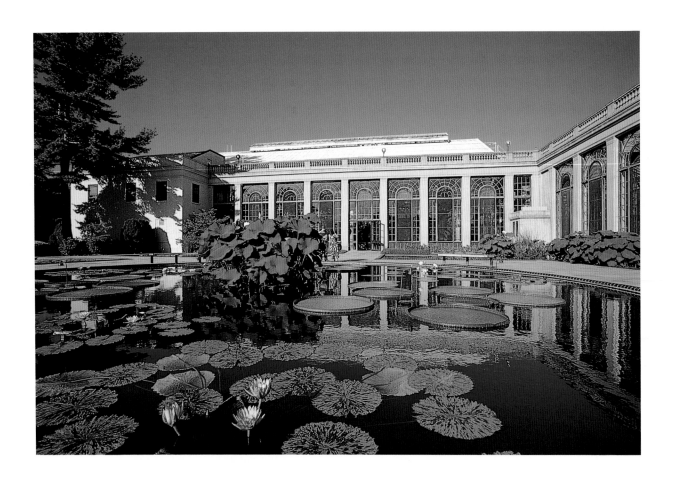

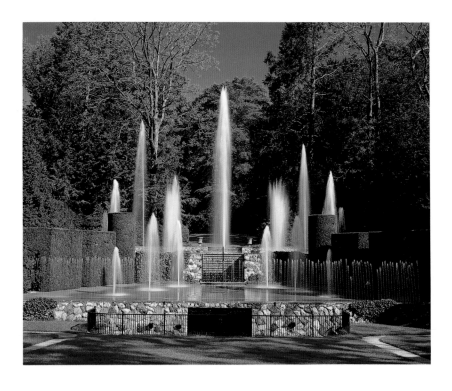

Above: Tropical waterlilies and Longwood hybrid waterplatters *Below:* Fountains in Open Air Theatre

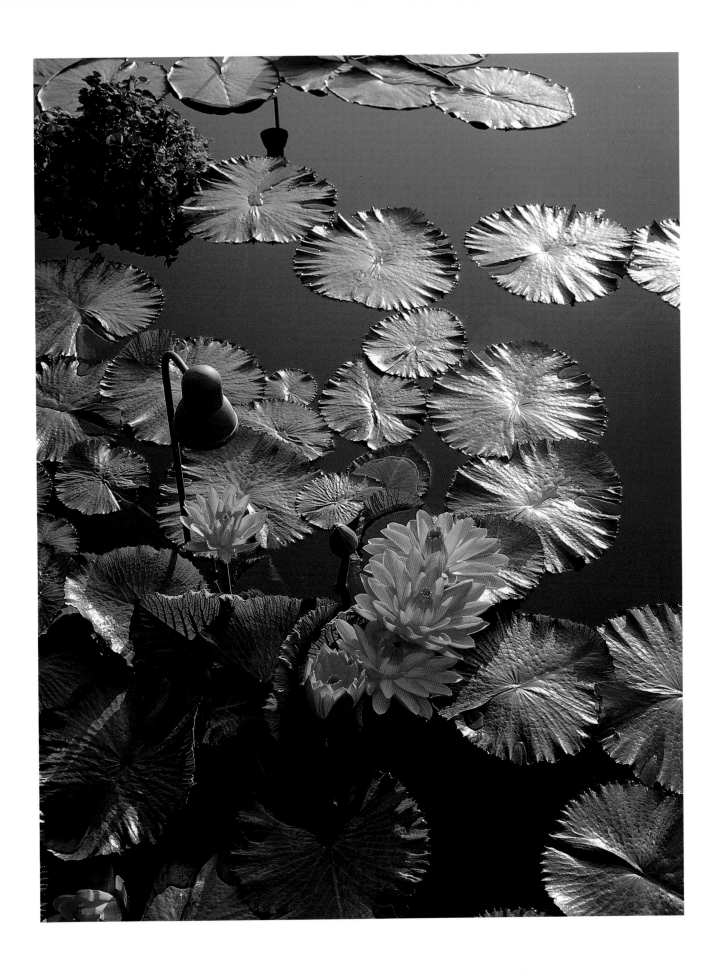

Above: Tropical nightblooming waterlily 'Mrs. George C. Hitchcock' *Overleaf:* Ivy geraniums in East Conservatory

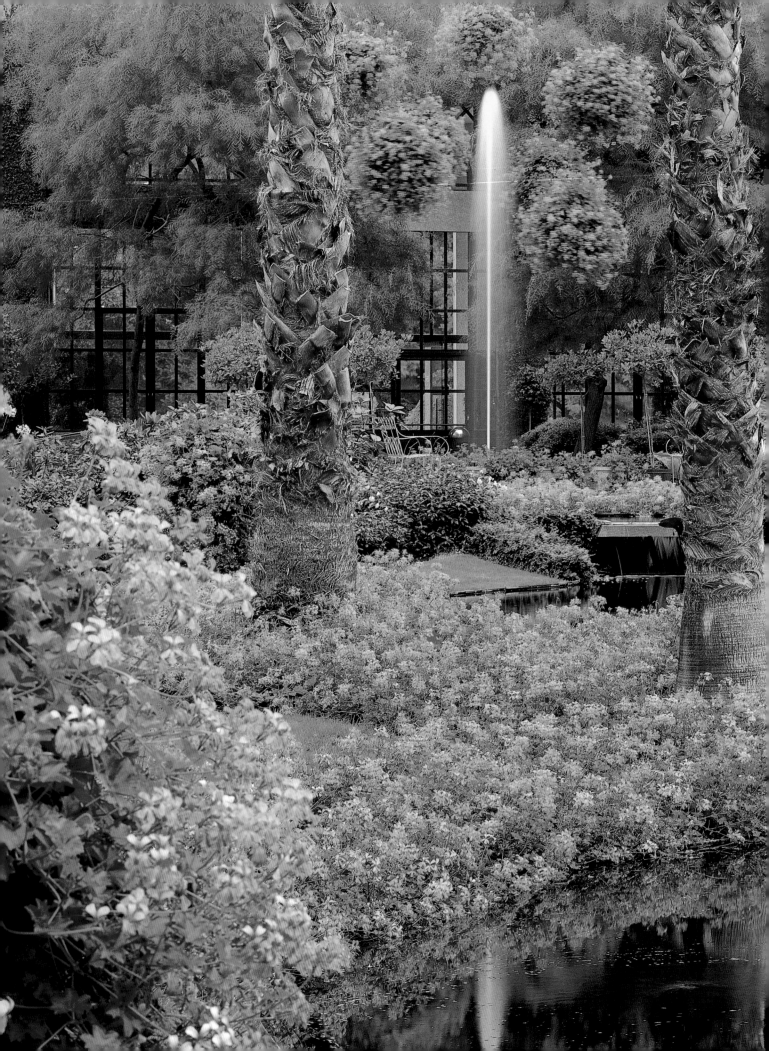

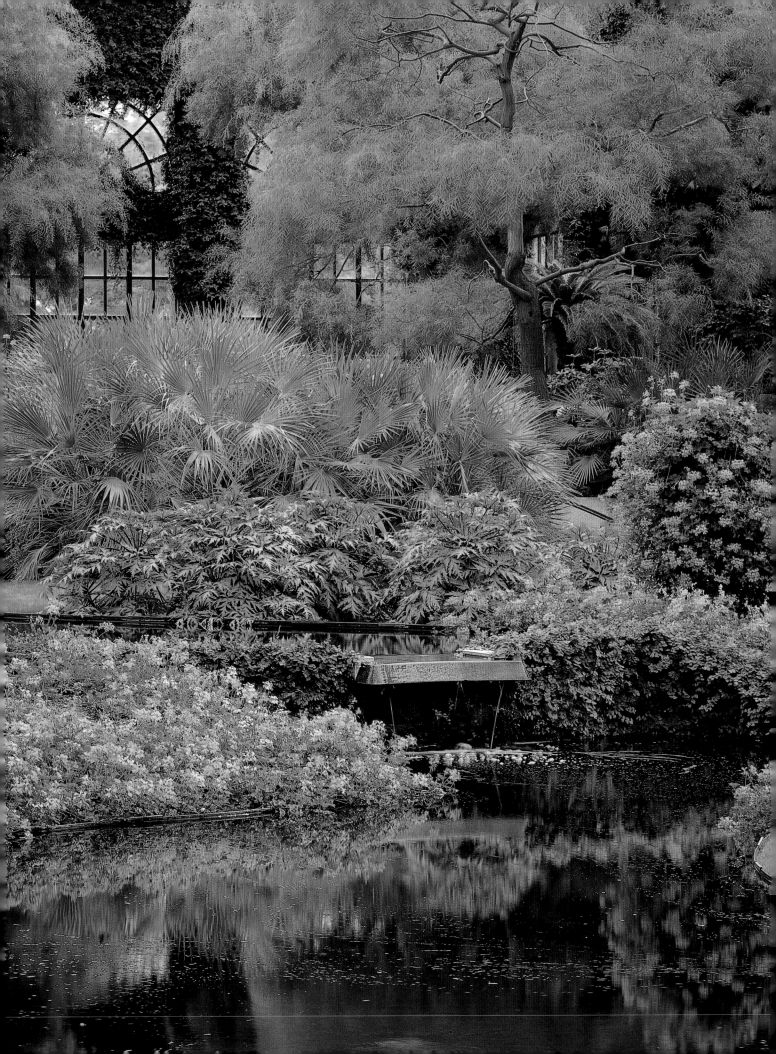

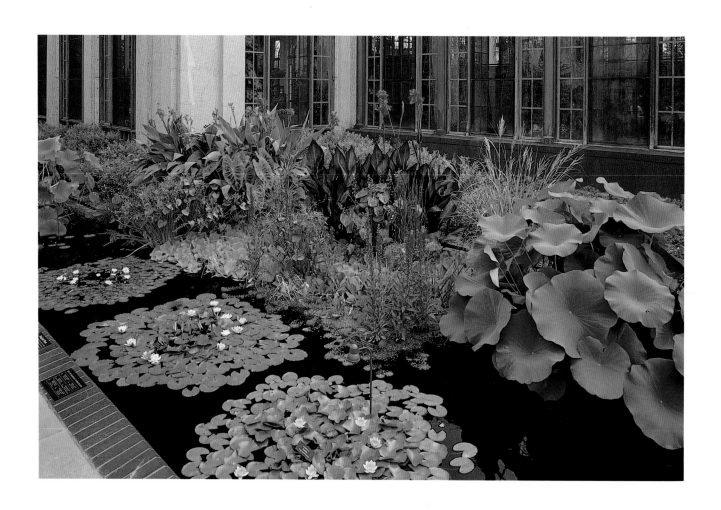

Above: Hardy waterlilies and pondside plants *Below:* Vegetables in Idea Garden

40

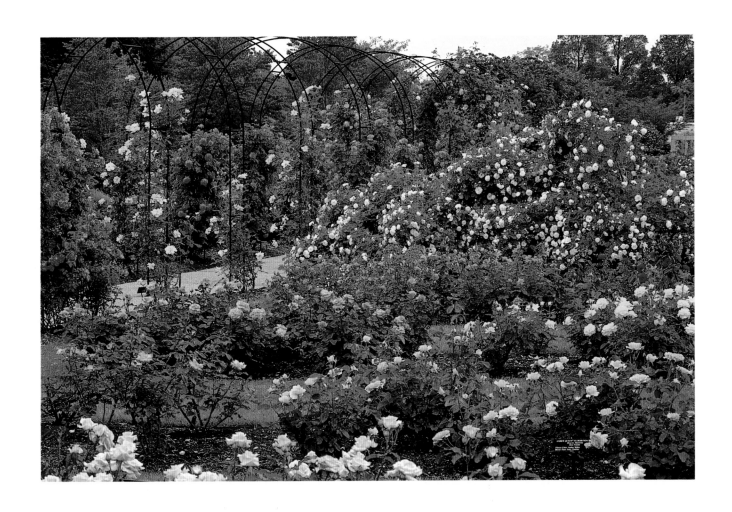

Roses in Idea Garden in June

41

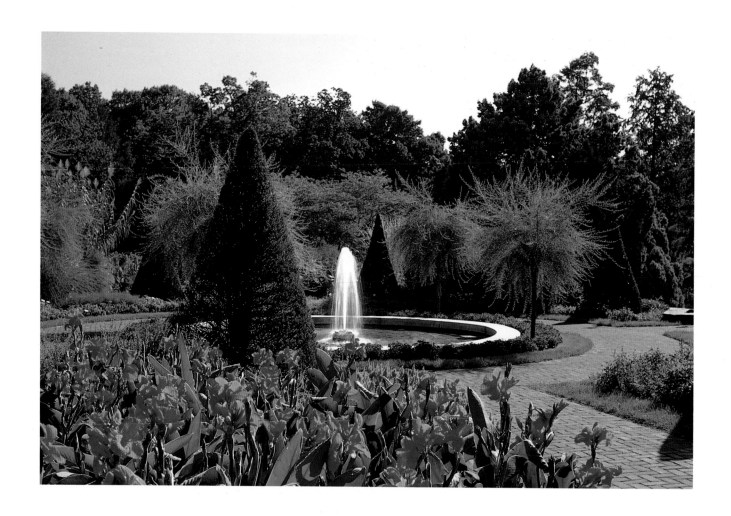

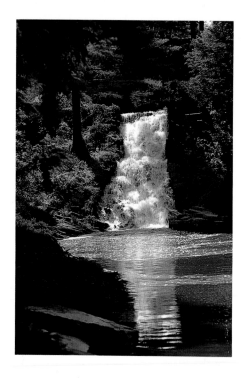

Above: Longwood hybrid cannas along Flower Garden Walk in September *Below:* The Waterfall

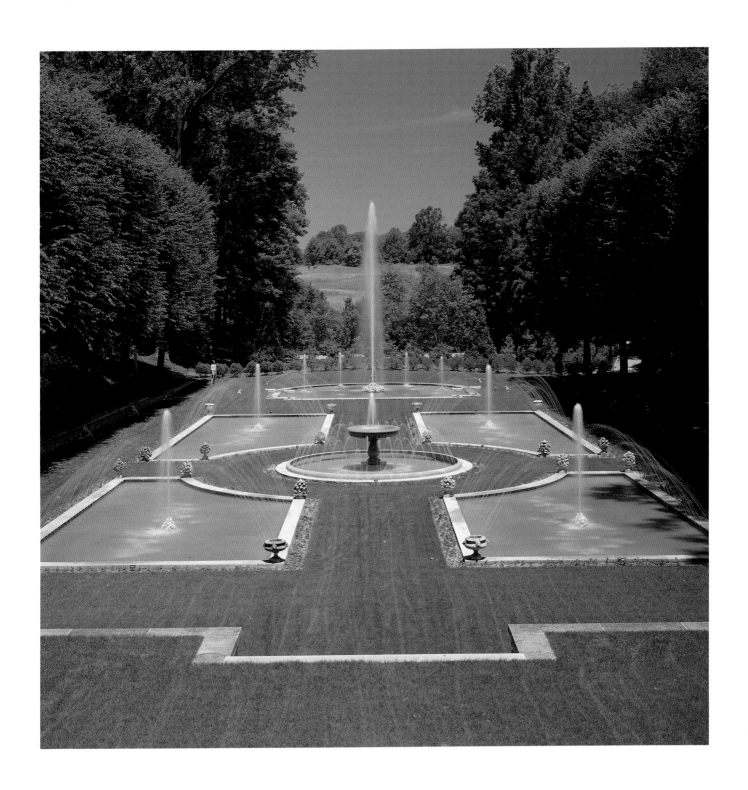

Italian Water Garden with 40-foot jet

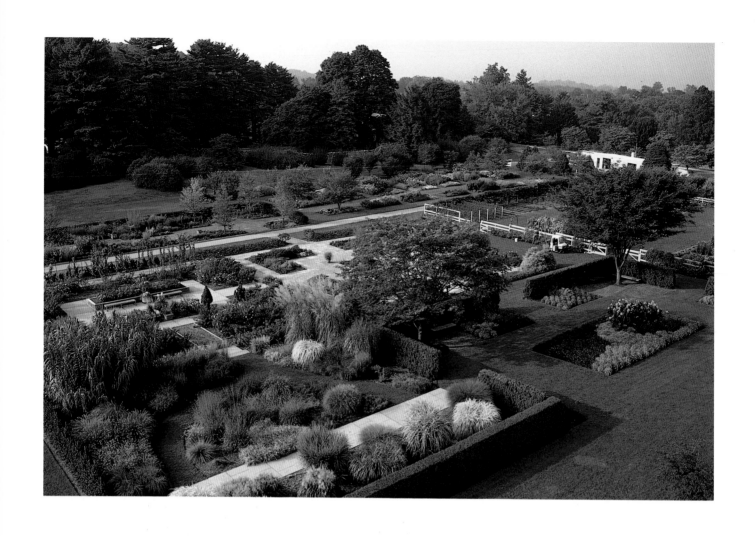

Idea Garden

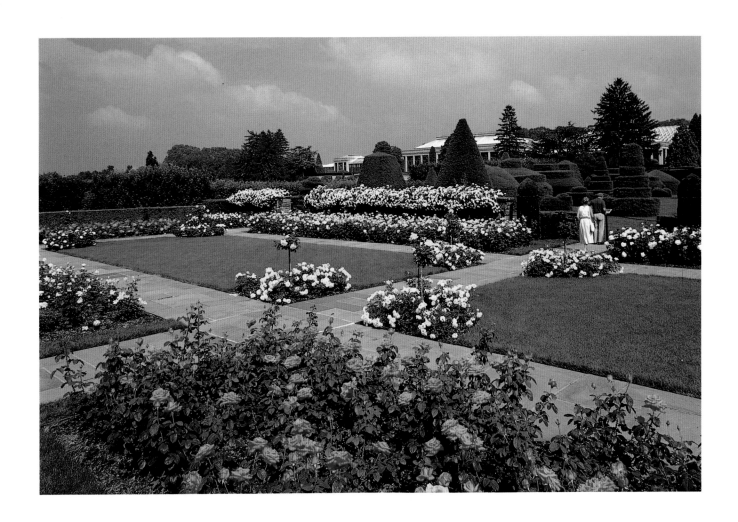

Above: Rose Garden in June *Below:* Hybrid tea rose

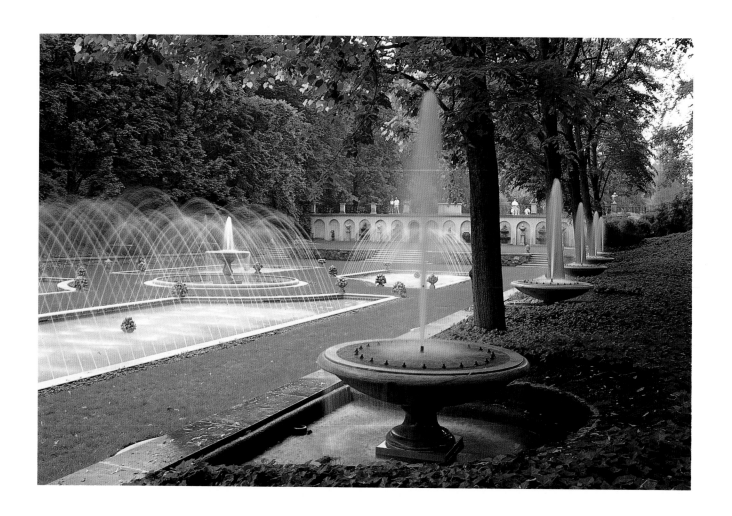

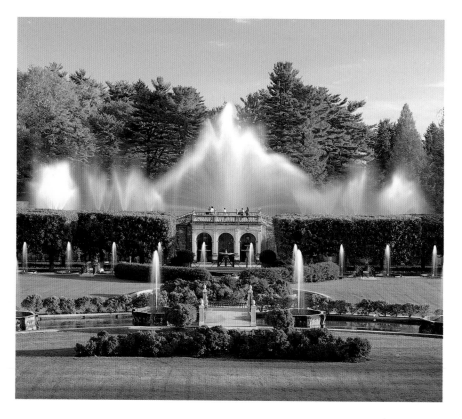

Above: Italian Water Garden *Below:* Hundred-foot-wide water fan in Main Fountain Garden

46

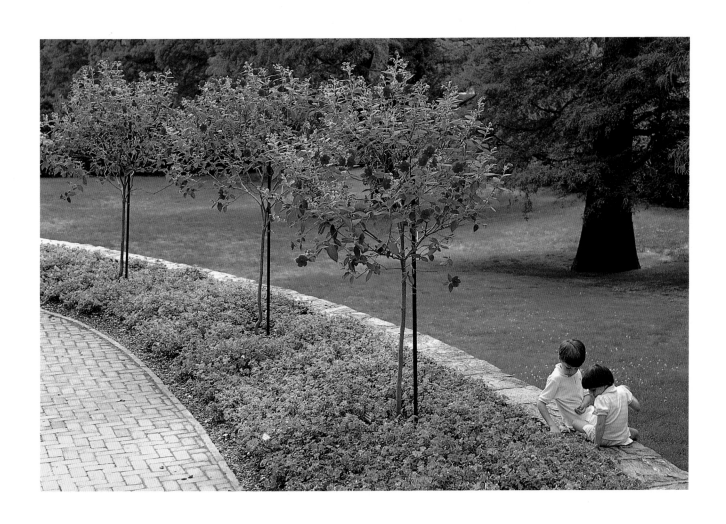

Impatiens and tibouchina standards

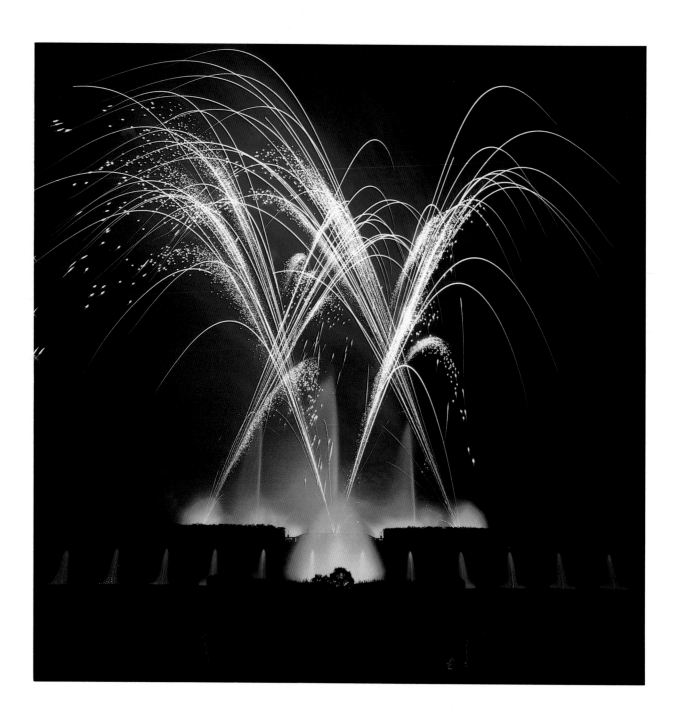

Fireworks and fountains

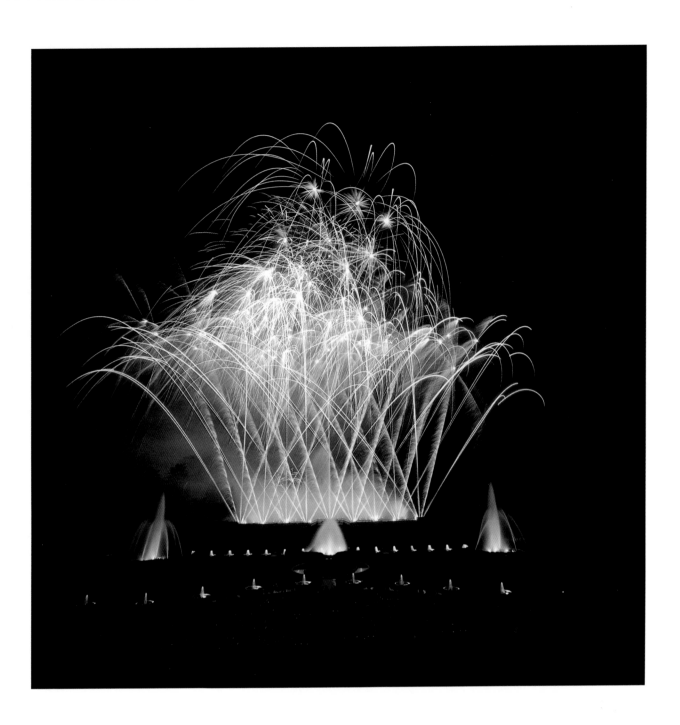

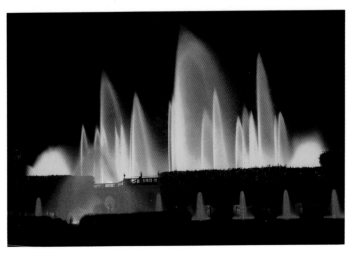

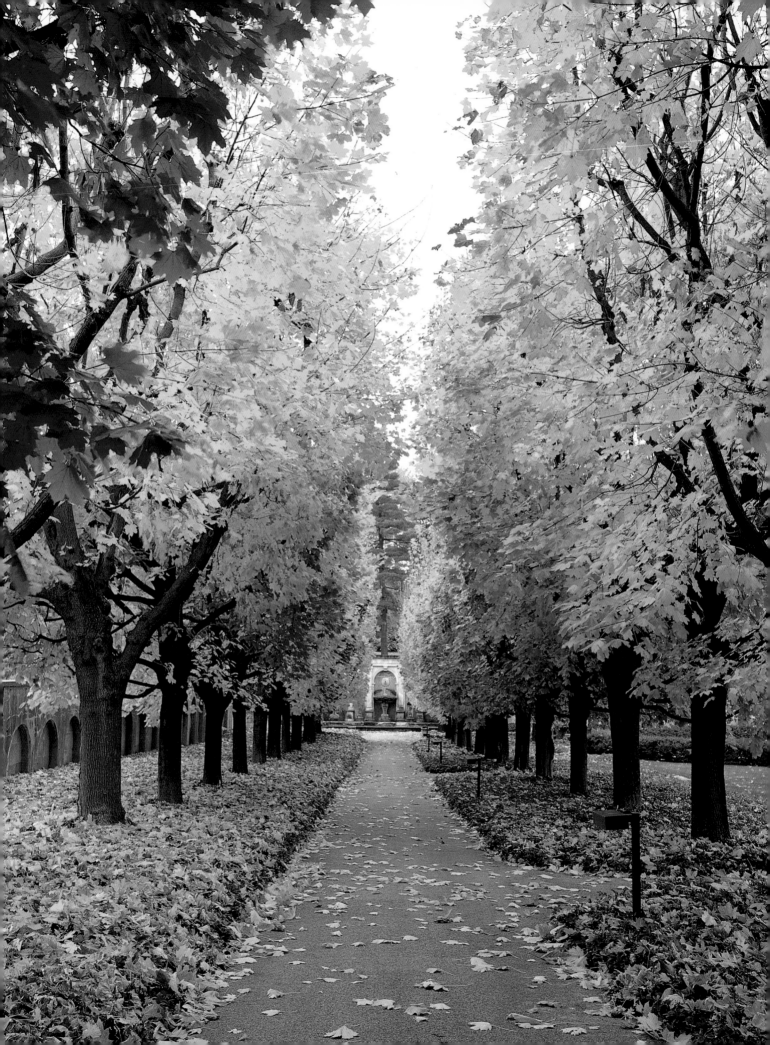

AUTUMN'S COLORS

After summer's haze, the exhilaration of autumn is welcome change. Clear skies and crisp breezes herald the new season and, before long, the landscape is ablaze with foliar fire.

Longwood's parade of brilliant colors lasts from mid-September through mid-November. The spectacle begins at different times for different trees, gradually building to a climax by mid-October.

Conditions are best when days are sunny and nights are cool but not freezing, with a mildly moist to slightly dry late summer and early fall. Autumn's shorter days and reduced light cause green chlorophyll in leaves to break down, revealing yellow pigments. Sugars trapped in the leaves are converted into red pigments, while browns result from tannins.

Longwood's fall palette reflects the diversity of trees growing throughout the gardens. The rich russet and clear reds of oaks and sour gums are intermixed with the deep green of conifers. The clear yellows of white ashes, the mottled golds and apple greens of towering tulip trees, and, especially, the fiery oranges of sugar maples vie for attention.

Golden honey locusts and ginkgos, scarlet sweet gums and sourwoods, and ruby northern red oaks add bursts of color. Copper beeches hover like golden bronze clouds. Deciduous conifers take on new disguises as European larches, dawn redwoods, and bald-cypresses turn clear yellow or bronze then drop their needles.

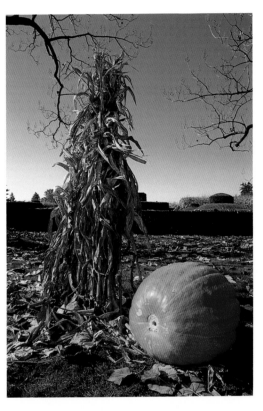

Closer to the ground, blazing red winged euonymus earns its common name, "burning bush." The textured Theatre Garden excels at subdued autumn hues while the Flower Garden Walk explodes with amber, burnt orange, deep crimson, and hot scarlet mums. The waterlilies in their final days are still glorious.

Careful observation reveals less obvious scenes of intimate charm. In the Hillside Garden, the yellow sternbergia and pink autumn-crocus appear as if by magic. Glossy nuts, brilliant berries, curiously shaped acorns, and spiral cones abound on Oak and Conifer Knoll. The fruits of mountain-ashes, hawthorns, and viburnums hang in jewel-like clusters, and the purple berries of callicarpa's cascading branches are downright bacchanalian. The round, red-orange fruits of Japanese flowering dogwoods, *Cornus kousa*, resemble plump raspberries; later, the arching branches are bedecked with red-purple leaves.

Autumn's spectral cornucopia recalls Longwood's heritage as one of America's first and finest arboretums, dating back to 1798. Its impending destruction in 1906 prompted Pierre du Pont to acquire the farm because he noted, "it seemed that the property was being denuded for the benefit of the owner before the maturity of the debts incurred for its purchase."

Pierre often expressed concern for trees. In 1908, he sought a man to prune "who will work absolutely under my direction, removing no branch, dead or alive, unless I specify it to be done." In 1932, he proposed that historic trees become semi-public property, that they be registered, and that even the owners be restricted from cutting, trimming, or injuring them.

Mr. du Pont planted thousands of additional trees at Longwood. Today these, along with the remaining Peirce plantings, are under the care of six arborists. The never-ending cycle includes, in winter, architectural pruning of maples and lindens; in spring, cleaning up winter storm damage, spraying dormant oil, and trimming Peirce's Park and the Open Air Theatre wings; in summer, clipping topiary and thousands of feet of hedges; and in the fall, stringing nearly 400,000 outdoor Christmas lights. Cabling for strength and cutting out dead wood are ongoing chores, and about 30 major trees are removed each year. Fortunately, the preventive measures taken to ensure healthy trees usually result in minimal damage from all but the most disastrous weather.

For most northern gardeners, autumn is a fitting finale to a year of horticultural labor, but not at Longwood. Here, the colors of the season are but a signal that it is time to move indoors and continue gardening.

Opposite: Norway maple allée in late October *Above:* Celebrating the harvest *Overleaf:* Flower Garden Walk before frost

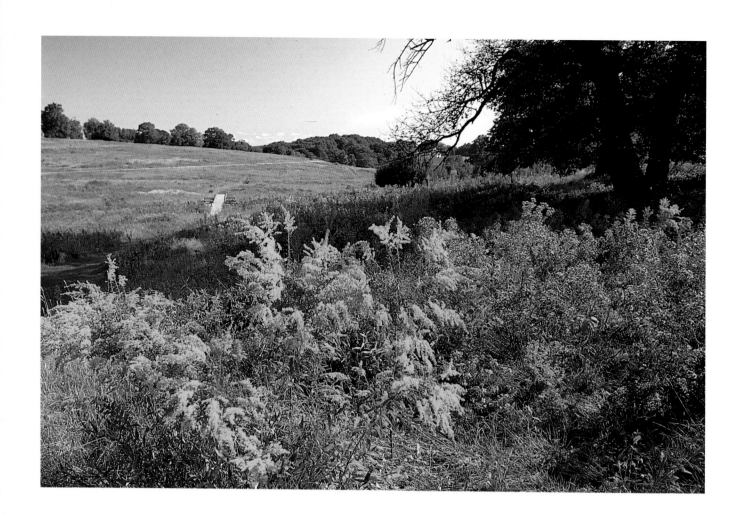

Above: Goldenrods and New England asters in Meadow *Below:* Ornamental grasses in Idea Garden

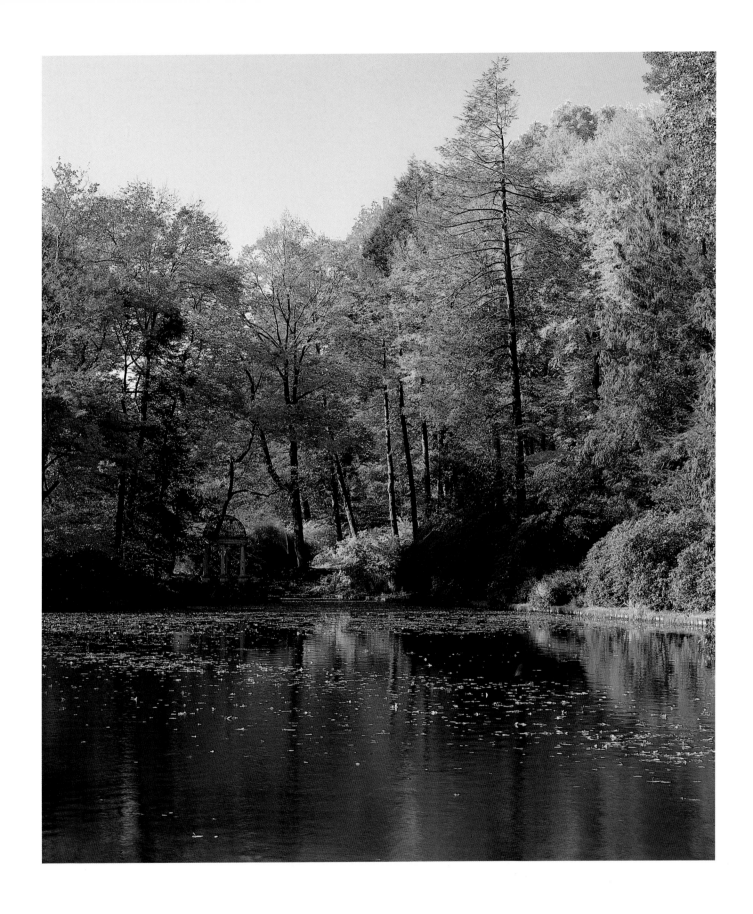

Large Lake in October

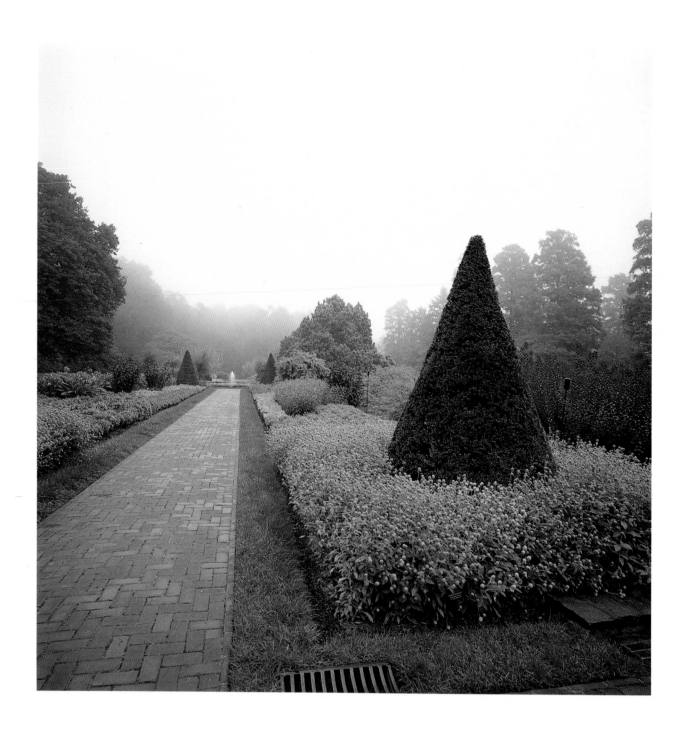

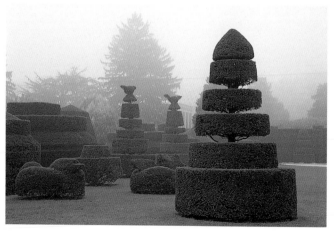

Above: Globe-amaranths and chrysanthemums along Flower Garden Walk *Below:* Topiary Garden

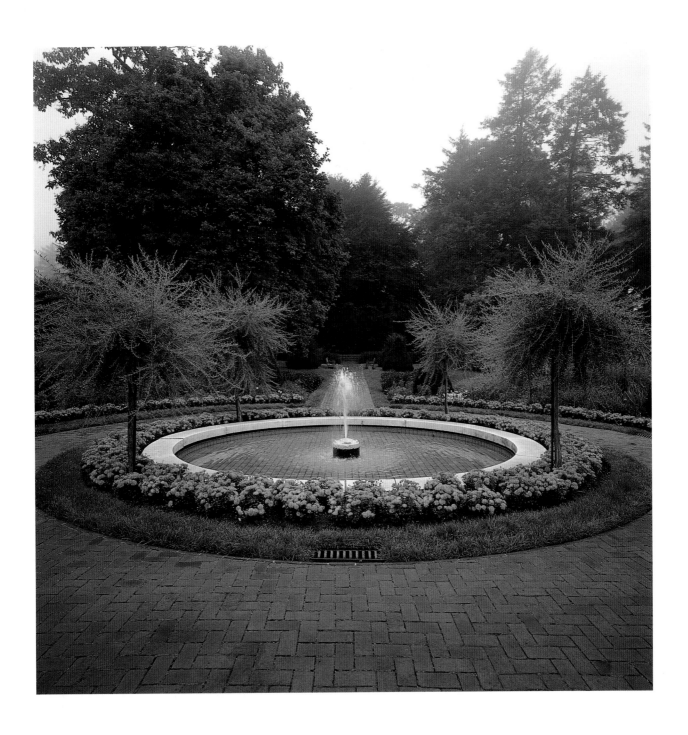

Round Fountain surrounded by chrysanthemums

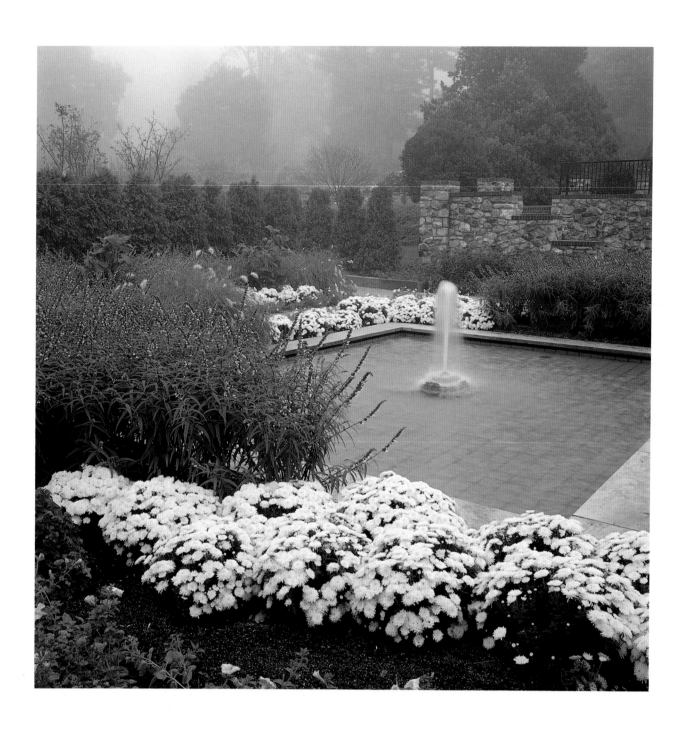

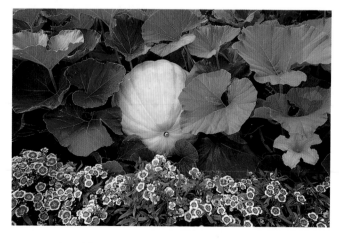

Above: Square Fountain with chrysanthemums and salvias
Below: Dianthus and pumpkin in Idea Garden *Opposite:* Peirce's Woods in October

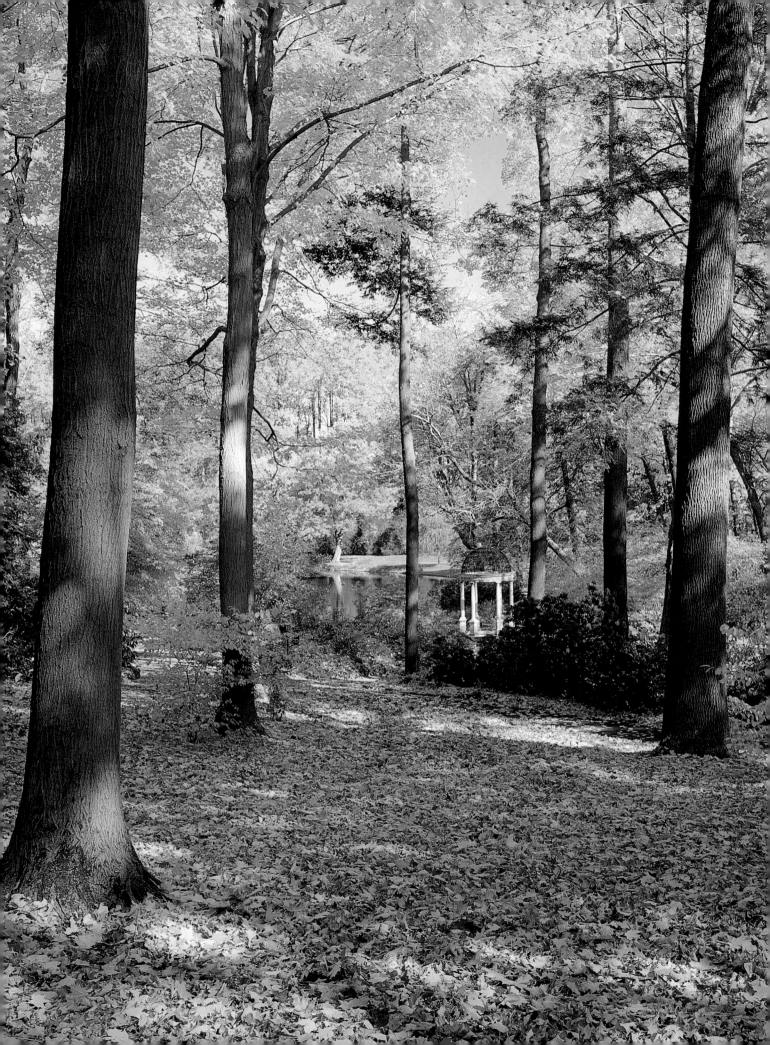

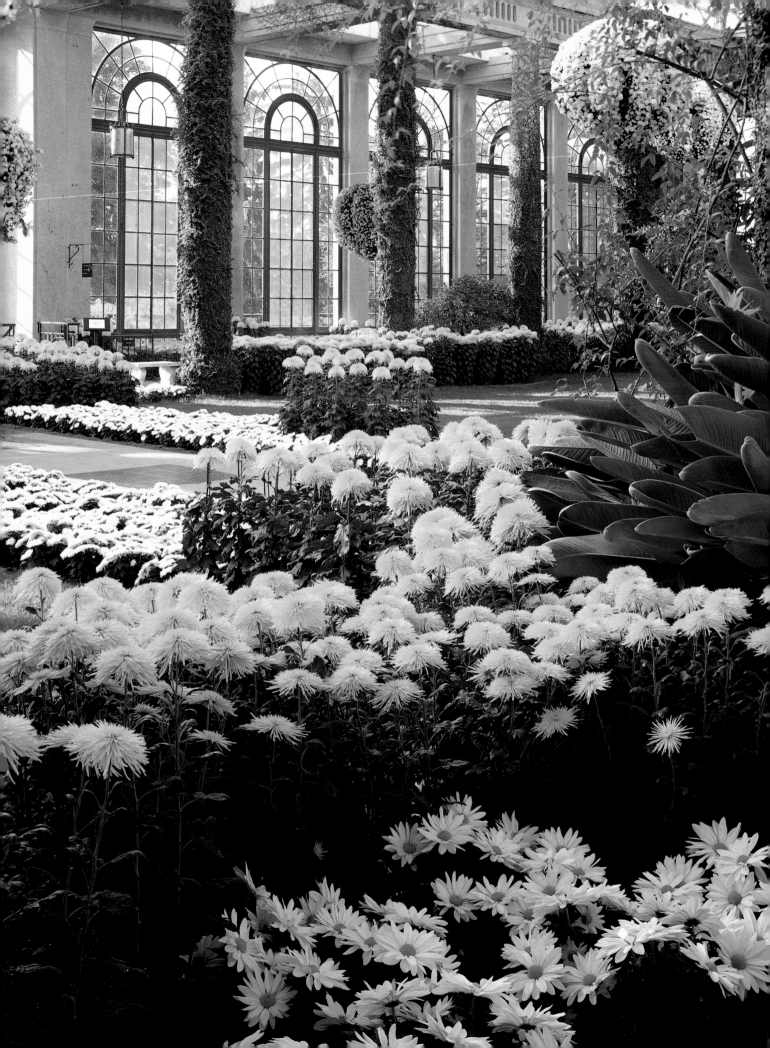

CHRYSANTHEMUM FESTIVAL

Just when frost has put an end to fall's outdoor color, Longwood breaks forth in what, floriculturally, is one of the year's most breathtaking sights. During November's Chrysanthemum Festival, 15,000 mums fill every nook and cranny of the Conservatory with waves of harvest color. This plethora of gold, bronze, yellow, maroon, rust, and white is perhaps the finest show of its type in the world.

The history of chrysanthemums at Longwood dates back to the beginning of the Conservatory. Mr. du Pont noted in 1922 that there had been a substantial exhibition of mums the previous year (probably for the official opening in November 1921). But the recorded history of the flower goes back 2,500 years when Confucius described it as a "yellow glory" and suggested that it be used as an object for meditation. Mums reached Japan from China in 386 A.D. and were proclaimed the Japanese national flower in 910. They were imported from China to Europe in the 1680s and into the United States in the late 1700s.

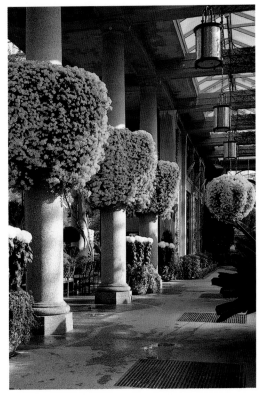

Early chrysanthemums were predominantly yellow, although a white form was discovered in China around 500 A.D. Today, because of extensive breeding, mums are available in yellow, pink, lilac, white, and shades of red and rust.

Blooms shapes vary greatly. To alleviate confusion, horticultural classifications have been developed to describe the various types, including single, semi-double, anemone, pompon, incurve, reflex, decorative, spoon, spider, quill, brush, and thistle. Most forms can be seen at Longwood during November.

As many as nine different techniques are used to train Longwood's mums. More than 2,200 pot mums are kept low and well branched with mounds of flowers. Over 1,100 exhibition-type single-stem mums are disbudded except for a seven-inch flower that crowns the stem. A dozen mums are grown as single-stem trees having a bare stem topped with bushy growth and many blooms. Free-form, cloud-pruned topiaries are fanciful and give an oriental effect, as do several "thousand-bloom" specimens. More traditional are a dozen small bonsai mums trained in various styles.

Most amazing of all are two dozen five-foot-diameter hanging globes and 96 cascades that drape the Conservatory walls and columns like flowery waterfalls. The largest "curtain," made up of several cascades, contains about 150 square feet of flowers. Growing upward are more than a dozen free-standing columns that add linear elements to the design.

Tremendous effort goes into making the mum exhibit a horticultural *tour de force*. Cuttings are taken in January for the globes and cascades or arrive already rooted from Florida and California in the summer. Five growers aided by students work with the plants off and on until October grooming, pinching, and shearing. Six gardeners then install and maintain the mums while on exhibit.

Arranging 15,000 mums in the Conservatory takes some skill. The displays into the 1960s used hundreds of different varieties in small assortments. A design approach has since evolved that uses larger masses and fewer varieties to complement one another and give a harmonious whole.

In 1981, the mum show was expanded into a month-long festival built around such themes as Oriental Heritage, Harvest Magic, Safari, The Wonderful Garden of Oz, In the Dragon's Garden, Where Dinosaurs Dwell, Birds in Paradise, and Alice's Wonderland. Visitors enjoy everything from crafts and food demonstrations to music, dancing, puppet shows, and whatever else is appropriate to a given theme.

What everyone remembers most are the fantastic topiary figures that have graced many of the festivals since 1984. These indoor characters have metal frameworks stuffed with sphagnum moss and covered with a variety of live materials, including ivy, creeping fig, ferns, spider plants, and succulents. Subjects have ranged from tiny ducks, bunnies, and roadrunners to life-sized elephants, giraffes, a carousel, 20-foot-tall pagoda, and 43-foot-long apatosaurus. The appeal is universal to young and old alike and makes the Chrysanthemum Festival one of the most eagerly anticipated events of the year.

Opposite: Orangery in November *Above:* Chrysanthemum cascades around Orangery columns

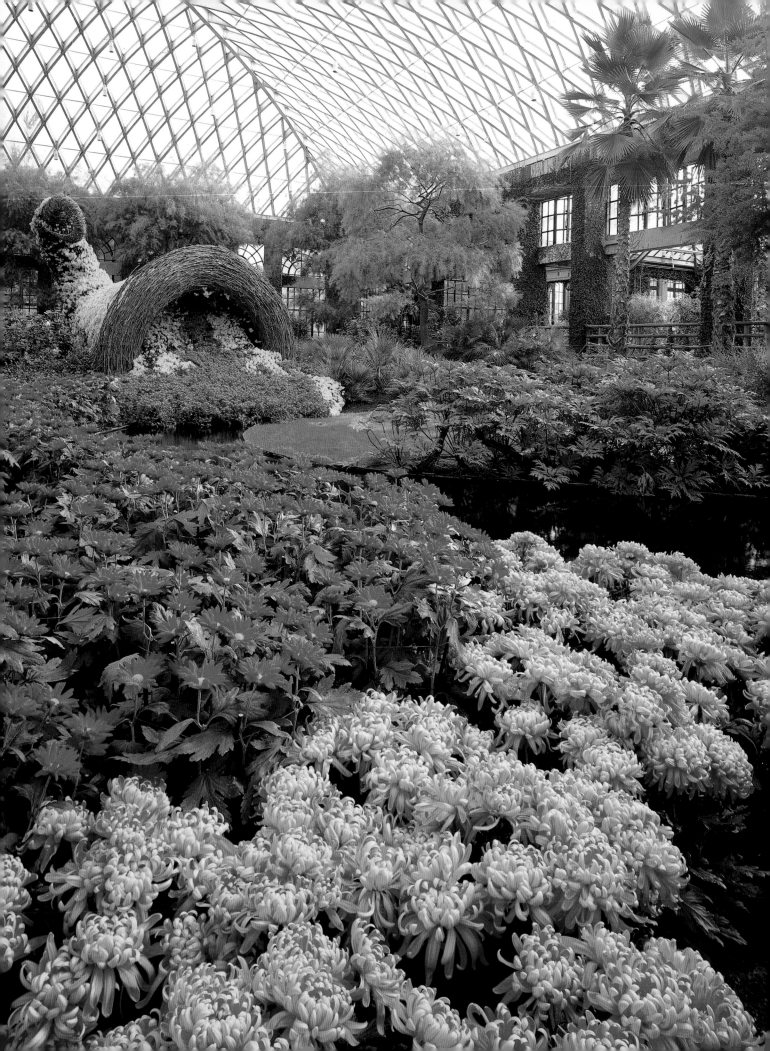

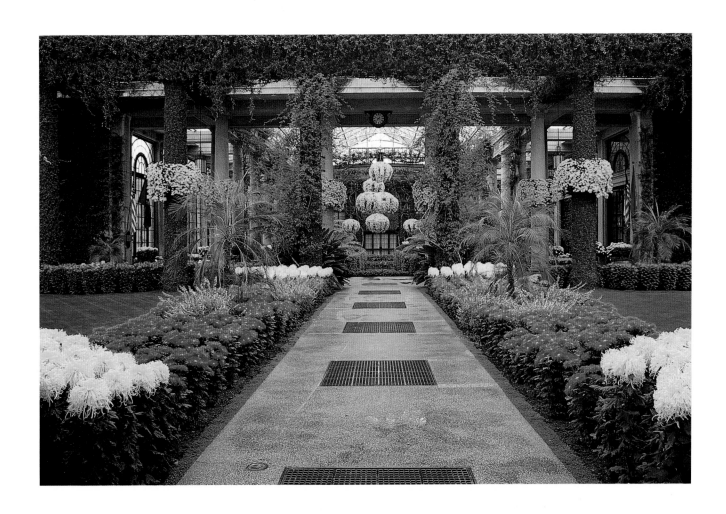

Opposite: Chrysanthemum cornucopia in East Conservatory *Above:* Center walk of Orangery
Below: 'Amber' semi-double chrysanthemums *Overleaf:* 43-foot-long ivy apatosaurus in Exhibition Hall

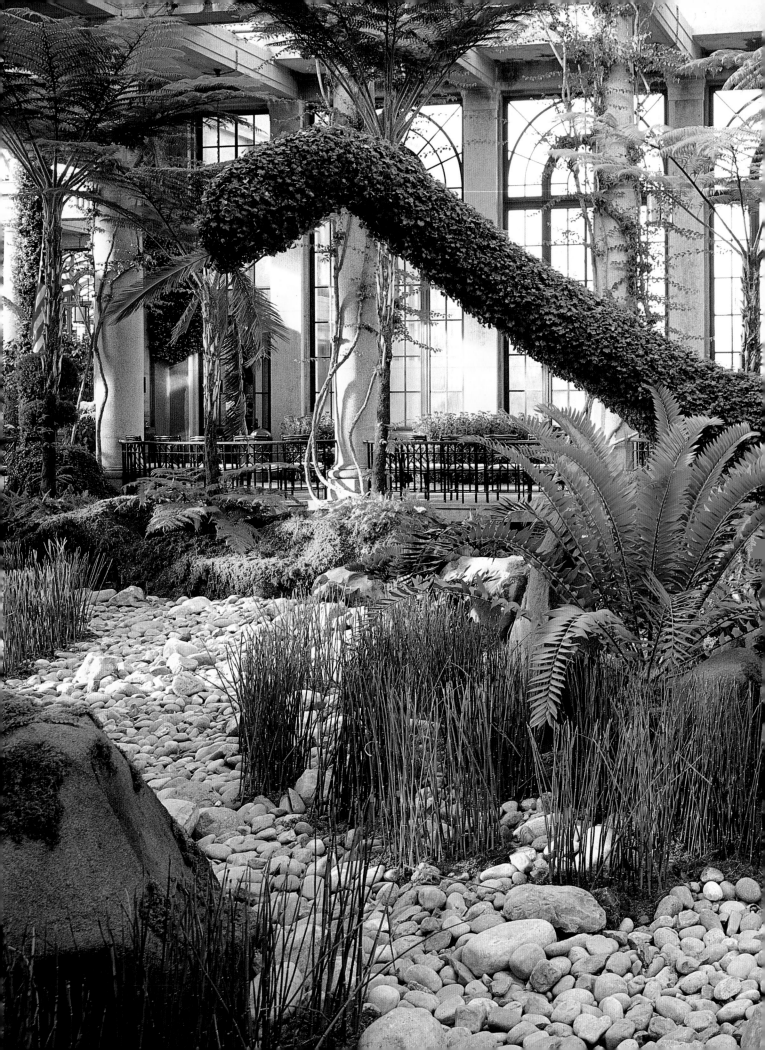

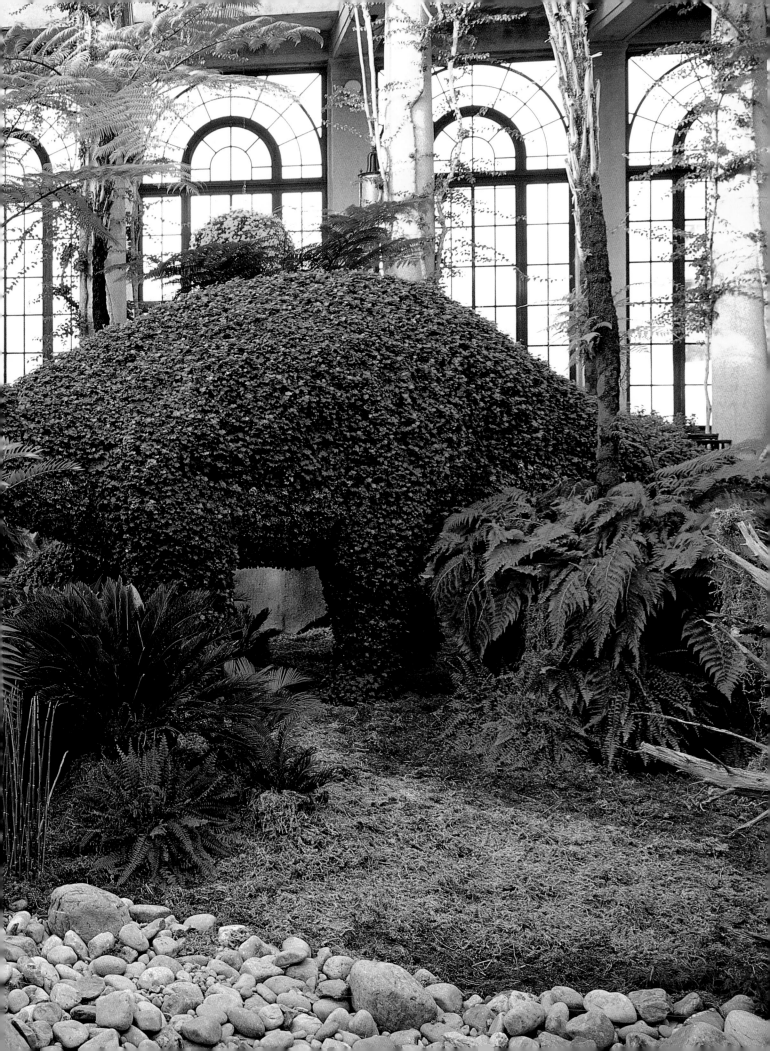

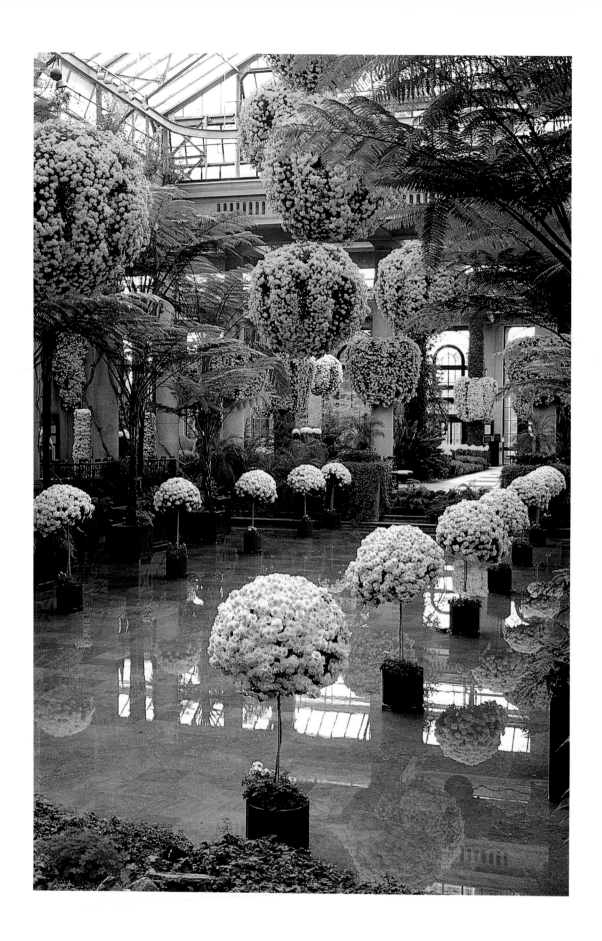

Chrysanthemum hanging baskets and standards in Exhibition Hall

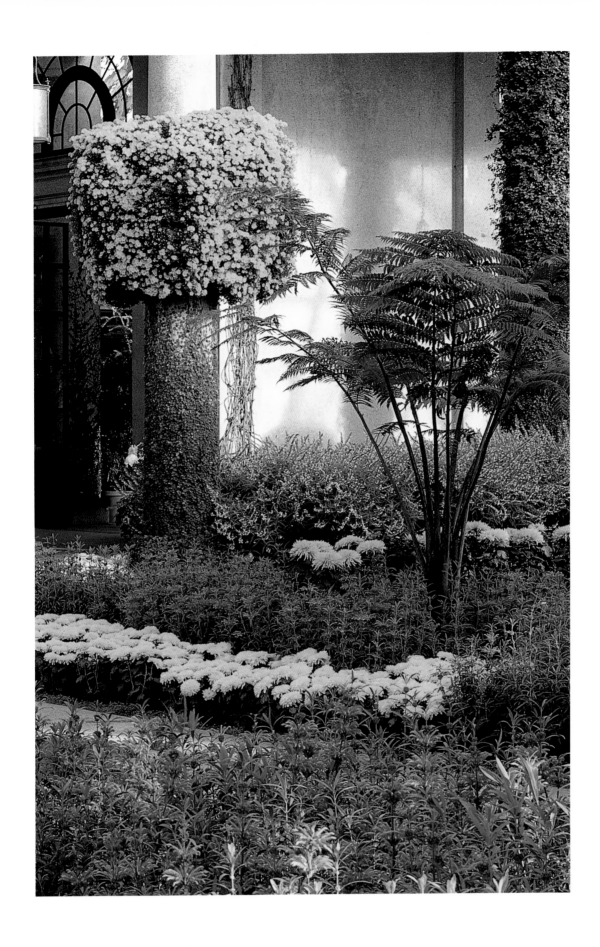

Orange lion's-tail, chrysanthemums, purple salvia in Orangery

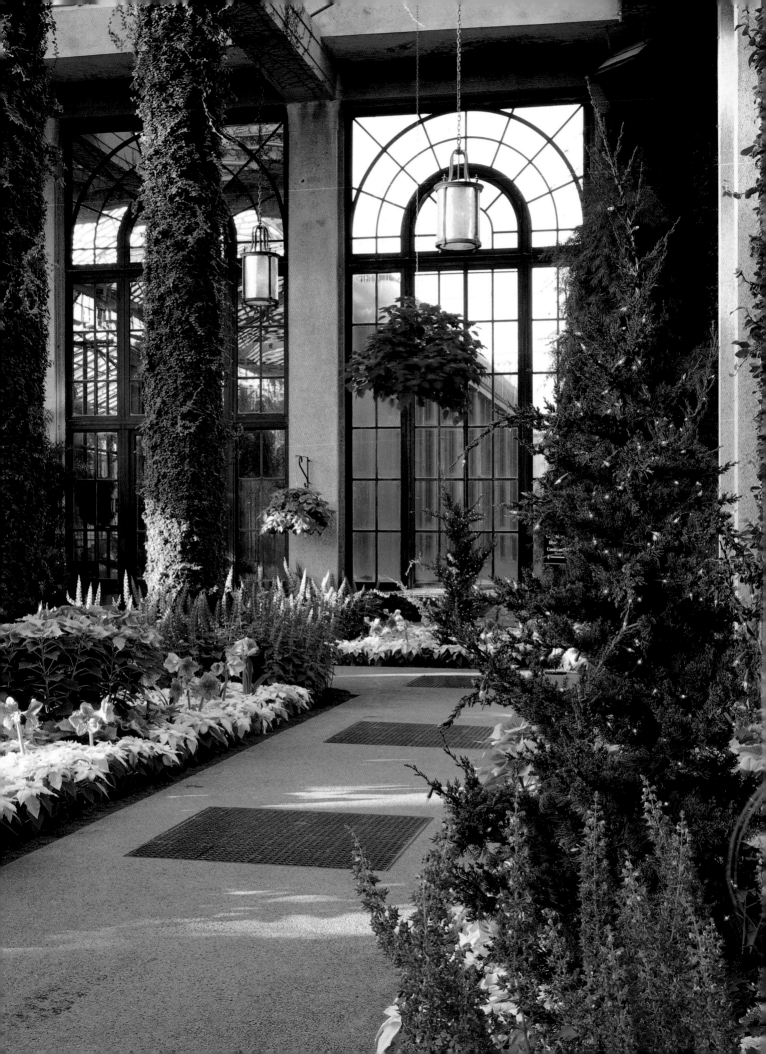

CHRISTMAS

After the excitement of spring, summer, and fall, one might think the Gardens would have earned a well-deserved rest. Yet December is the busiest month of the year, with as many as 200,000 visitors enjoying a Longwood Christmas.

A horticultural celebration of the holidays is a relatively recent development. In 1922, poinsettias bloomed in one of the smaller greenhouses, but there was not a major poinsettia display until 1957. In 1962, the display was expanded to 1,000 poinsettias combined with white flowering begonias and spring bulbs. The new parking lot was turned into "Christmas Tree Lane" for six days with the lighting of three evergreens and an eight-foot wreath for two hours each night.

From these modest beginnings Longwood's Christmas has blossomed into an annual extravaganza with a different theme each year. Decorated trees are always a highlight, with at least one huge tree laden with flowers or ornaments as an indoor centerpiece.

The mainstay of the indoor display is the poinsettia, introduced to this country from Mexico in 1825 by Joel Poinsett. Longwood grows more than 2,000 plants each year from rooted cuttings flown in from California between June and August. Two growers tend them over six months under greenhouse conditions. Red, pink, and cream-colored cultivars are grown as single stem plants, standards, and hanging baskets; these last are suspended high above the display like giant Christmas baubles.

Other crops include amaryllis, begonias, calla lilies, blue coleuses, Christmas cactus, cyclamens, blue irises, Jerusalem-cherries, narcissi, primroses, stevias, and tulips. On Sunday evening before Thanksgiving, the mum display is removed and the Christmas crops are plunged into the Conservatory borders over the three busiest workdays of the year.

Outdoors, the Gardens are a twinkling wonderland for four hours each evening. From modest beginnings in 1962, the Christmas lighting has grown to nearly 400,000 lights covering both evergreen and deciduous trees as well as wire frames. Longwood's arborists and electricians work hard during October and November to string the lights between the Visitor Center and the Conservatory. Often they construct a twine framework around a tree onto which a spectacular lighted cone can be superimposed regardless of the tree's real shape.

Fountains are now as much a part of Christmas as they are of the warm weather months. The Main Fountains are too exposed for winter use, but the Open Air Theatre fountains can be used during December. In 1987, Theatre fountain displays set to holiday music were initiated each evening for four hours. The plumbing is below the stage in a heated room, and only when the temperature falls well below freezing must the system be shut down. Against a backdrop of lighted trees, the continuously repeating five-minute fountain show ends with compressed air blasting the jets sky high, to the crowd's delight.

The final element for holiday cheer is music, which has grown from one organ concert during the 1962 Christmas display to about 200 organ and choral concerts during December. The 10,010-pipe organ in the Ballroom is the major music maker. It was built in 1929 with 146 ranks (or sets) of pipes, 237 stops and couplers, five 32-foot pedal stops, 364 percussion tones, 61 combination pistons, and a nine-foot Weber concert grand piano playable from the organ console. The organ weighs 55 tons and is installed in nine chambers that together are 63 feet wide, 23 feet deep, and 40 feet tall. Wind is supplied by electric blowers totalling 72 horsepower. The instrument is perhaps the world's largest residence organ (although the Wanamaker Organ in Philadelphia, three times as large, is the world's largest playable instrument). Longwood's is a superb example of a full-blown, red-blooded American orchestral organ.

The organ is but another manifestation of Pierre du Pont's remarkable vision that combined horticulture, architecture, theatre, and music into a unique garden experience. To this add a 200-year-old love of plants, and the skills and devotion of modern-day horticulturists and craftsmen, and it's easy to see why Longwood is perhaps the ultimate garden treasure.

Opposite: Blue coleus, pink amaryllis, poinsettias *Above:* Detail of decorative fan above Orangery entrance

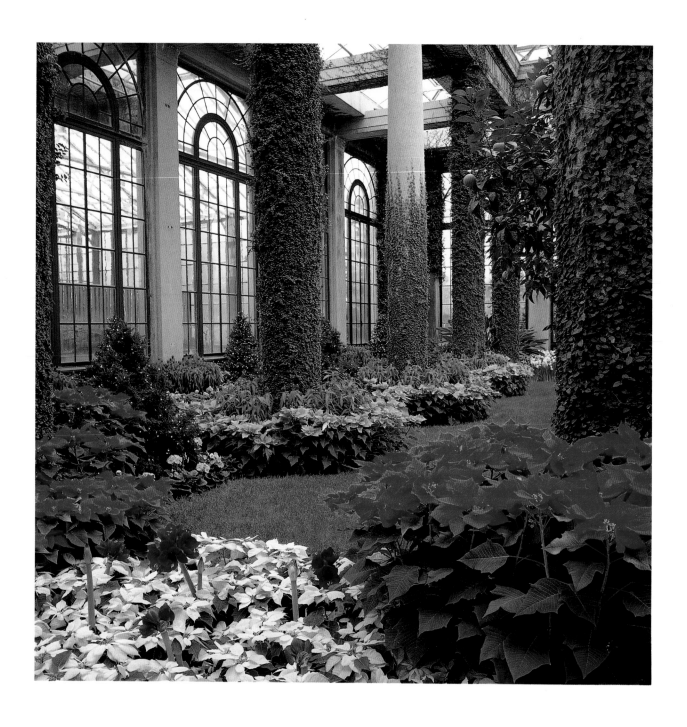

Orangery in December

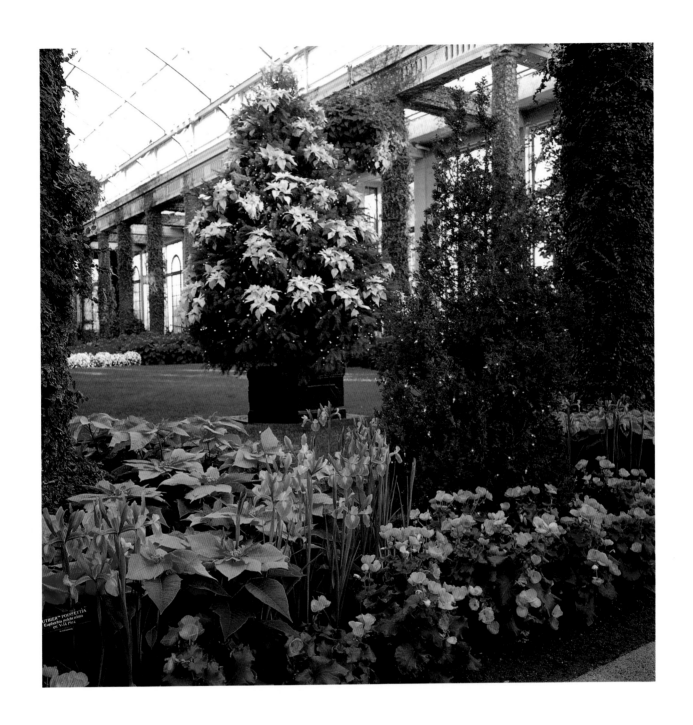

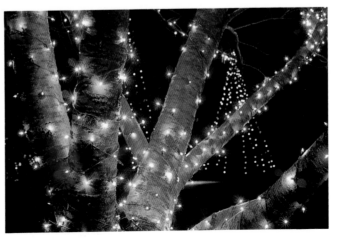

Above: The flowers of Christmas *Below:* A few of 400,000 lights *Overleaf:* Snowy landscape

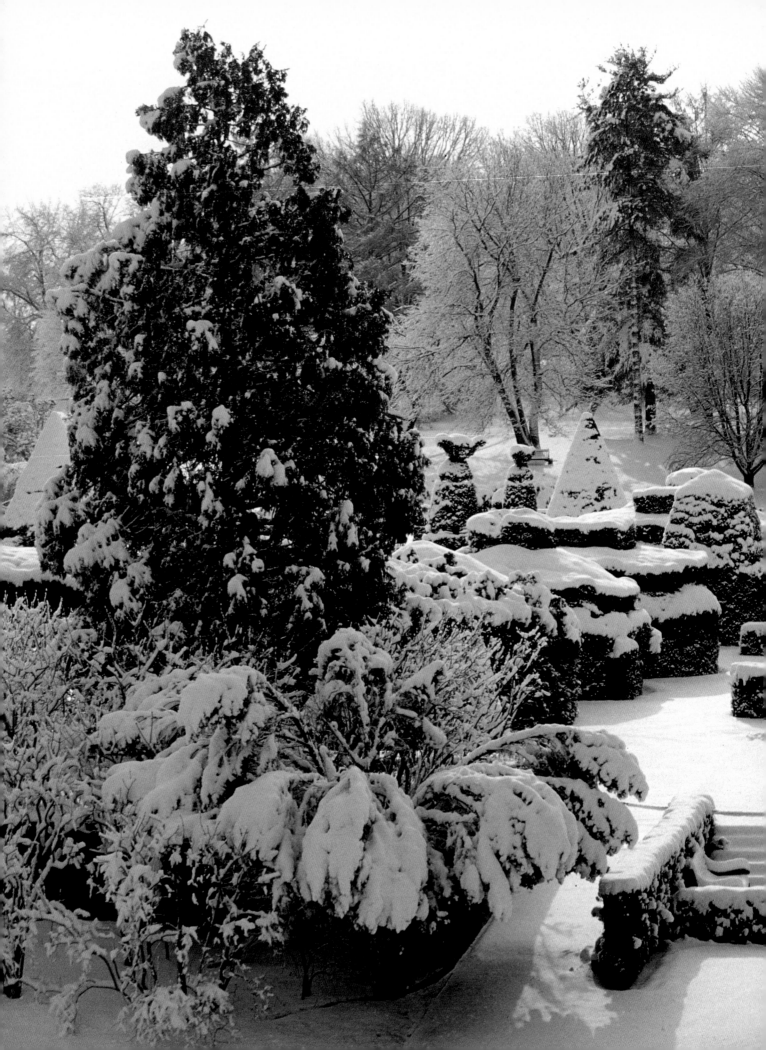

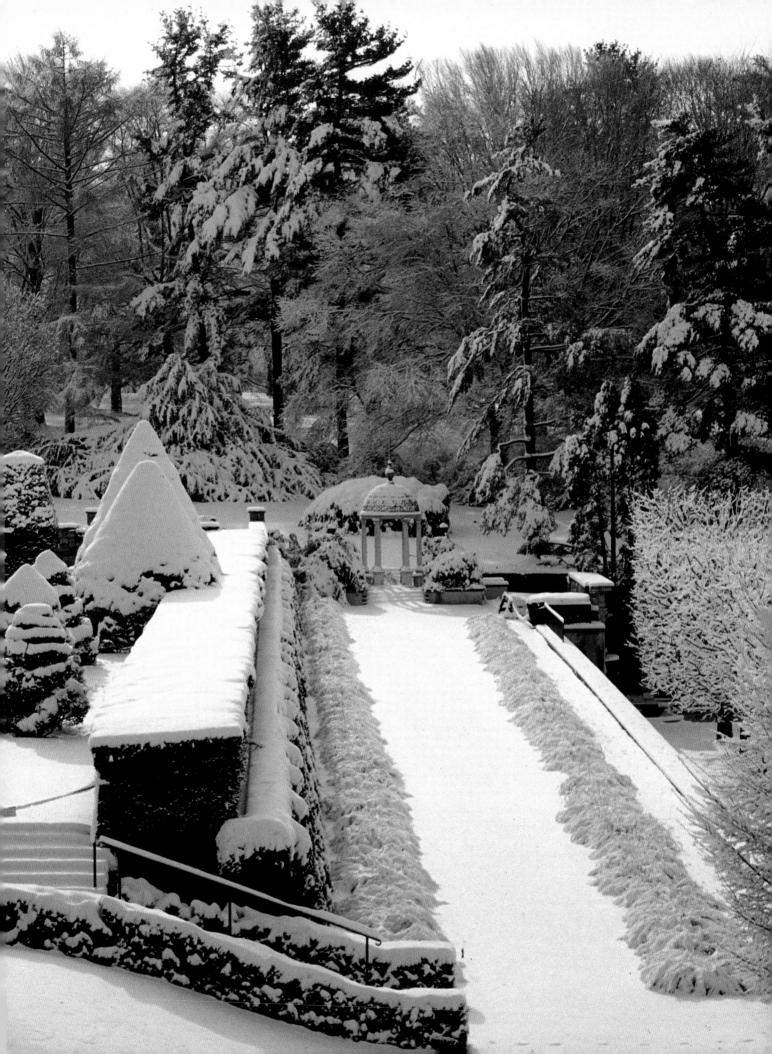

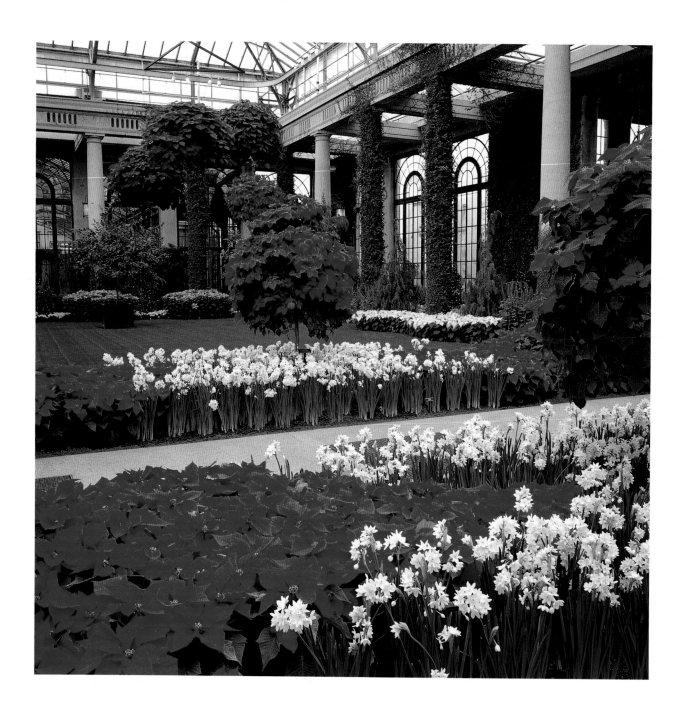

Red poinsettias, fragrant paperwhites

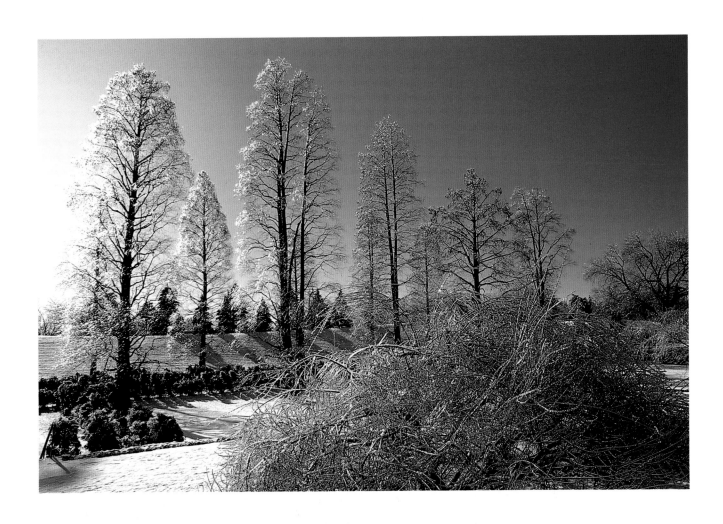

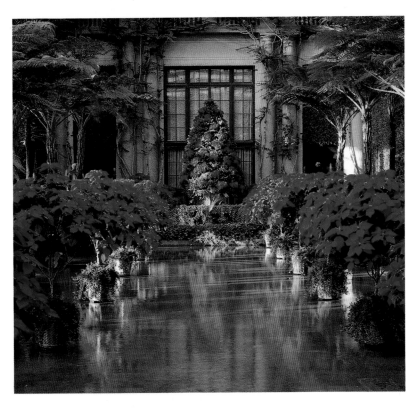

Above: The Gardens coated with ice *Below:* Poinsettia allée in Exhibition Hall

75

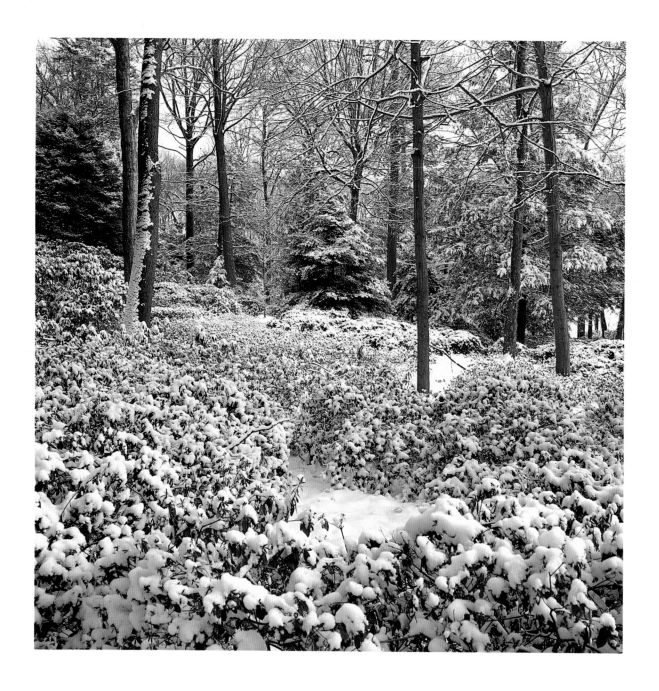

Peirce's Woods

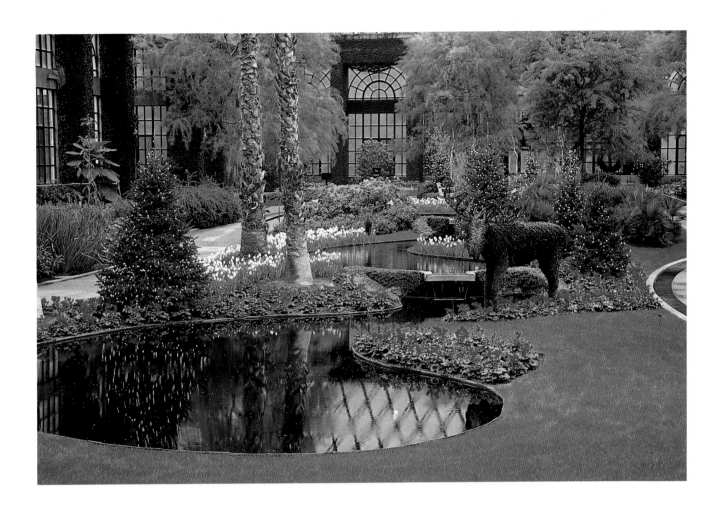

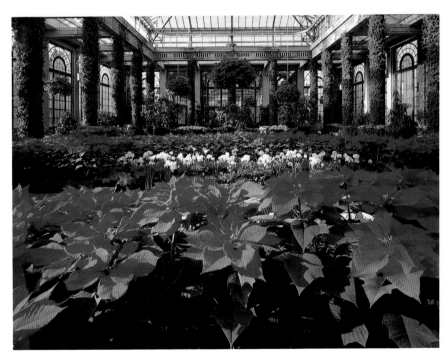

Above: Grapevine moose enjoying East Conservatory *Below:* Poinsettias in Orangery

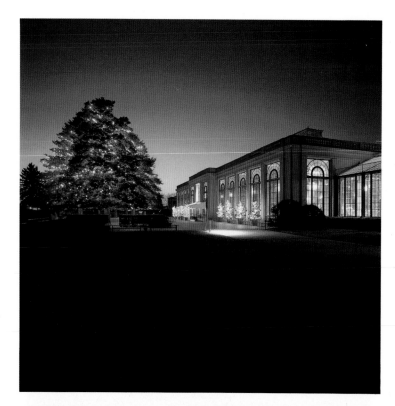

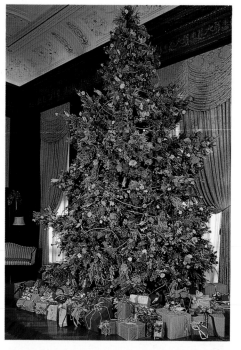

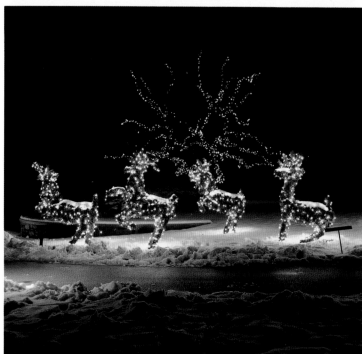

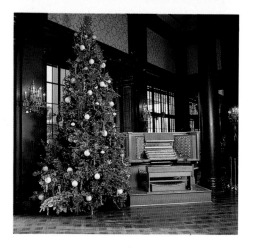

Conservatory at dusk
Electrifying reindeer

Dried flower tree in Music Room
Lights too numerous to count
Organ console in Ballroom

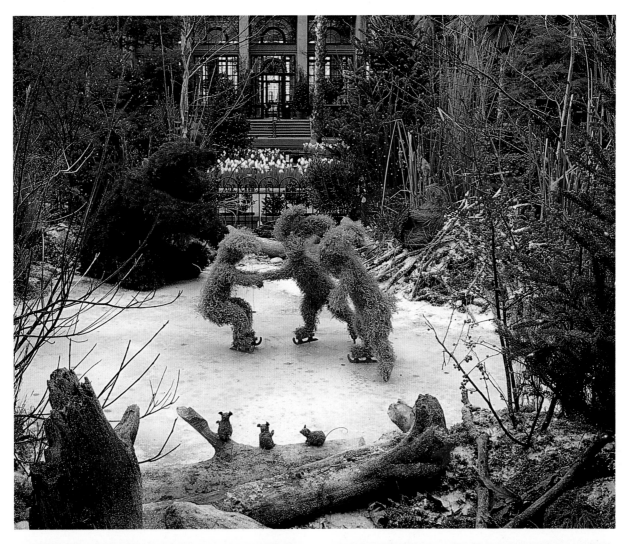

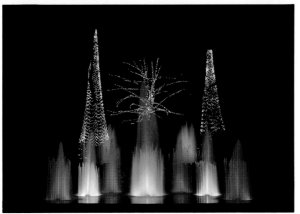

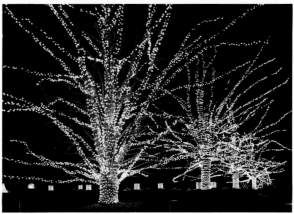

Skating bunnies with sea-lavender fur
Christmas fountains in Open Air Theatre

Glittering beech trees

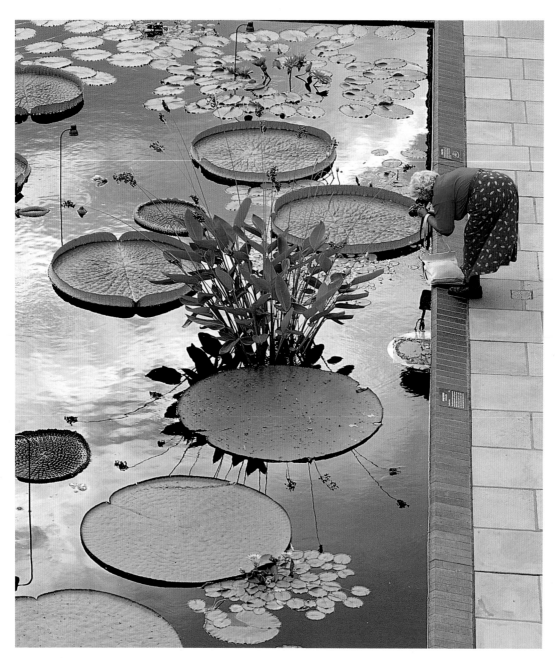

Victoria cruziana (top) is crossed each year with *Victoria amazonica* (bottom)
to create the Longwood hybrid waterplatters shown on page 36.

Copyright © 1995, text © 1992 by Longwood Gardens, Inc.

This book, or portions thereof, may not be reproduced
in any form without the written permission of
Longwood Gardens, Inc.

All rights reserved

Edited by James B. Patrick

Designed by Donald G. Paulhus

Produced by Fort Church Publishers, Inc.
Little Compton, Rhode Island 02837

Printed in Japan

Published by and distributed by
Longwood Gardens, Inc., Post Office Box 501
Kennett Square, Pennsylvania 19348-0501
Telephone 610-388-1000

Longwood Gardens